Wallace Herndon Smith *Paintings*

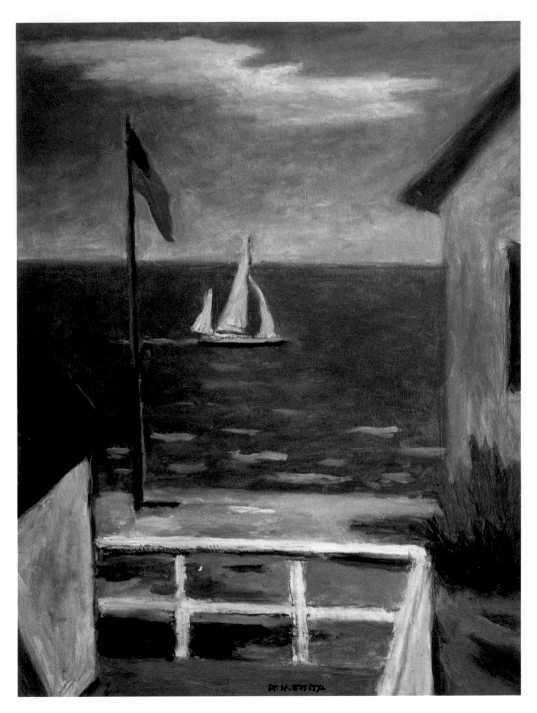

Nantucket, c.1959 oil on board, 31″ × 24″

Wallace Herndon Smith *PAINTINGS*

LEE HALL

Published for the Division of Arts and Communications

Academy for Educational Development, *New York,* by the

University of Washington Press, *Seattle and London*

This book is dedicated with affection and abiding admiration
to **MEREB MOSSMAN,** my dean at the Women's College of the University of
North Carolina, and my friend

Copyright © 1987 by the University of Washington Press
Composition by Birmy Graphics, Miami, FL
Printed and bound by Toppan Printing Company, Tokyo, Japan
Designed by Audrey Meyer

Library of Congress Cataloging-in-Publication Data

Hall, Lee.
 Wallace Herndon Smith: paintings.

 Bibliography: p.
 1. Smith, Wallace Herndon, 1901– 2. Painters—
United States—Biography. 3. Smith Wallace Herndon,
1901– —Catalogs. I. Academy for Education
Development. Division of Arts and Communications.
I. Title.
ND237.S6324H3 1987 759.13 86-26562
ISBN 0-295-96460-X

Contents

Flowers on a Striped Cloth, 1973 oil on board, 36″ × 24″

Exhibitions of Work
by Wallace Herndon Smith

1930 The Artists Guild, St. Louis, Missouri (awarded landscape prize)

1930 The American Water Color Society, winter show, New York

1931 The Artists Guild, St. Louis

1932 Newhouse Galleries, St. Louis

1933 Museum of Modern Art, New York

1939 Reinhardt Gallery, New York

1940 Associated American Artist Galleries, New York

1943 Eleanor Smith Galleries, St. Louis

1946 Associated American Artist Galleries, New York

1948 Carroll-Knight Gallery, St. Louis

1951 Safron Galleries, Clayton, Missouri

1953 Bernheim-Jeune Galleries, Paris

1955 Argent Gallery, New York

1957 The Artists Guild, St. Louis

1959 California Palace of the Legion of Honor, San Francisco

1961 Norton Gallery of Art, West Palm Beach, Florida

1965 Painters Gallery, St. Louis

1967 Frank Rehn Gallery, New York

1971 Frank Rehn Gallery, New York

1974 St. Louis Art Museum, St. Louis

1975 The Messing Gallery, St. Louis Country Day School, St. Louis

1979 The Artists Guild, Webster Groves, St. Louis

1985 Missouri Botanical Garden, St. Louis

1985 The Childs Gallery, New York

1986 Washington University, St. Louis

1986 The Artists Guild, Centenary Exhibit, St. Louis

1986 Armstrong Gallery, New York

List of Paintings *(in order of appearance)*

Front matter illustrations: *Nantucket*, c. 1959; *Flowers on a Striped Cloth*, 1973; *The Green Cafe, Portugal*, 1970s; and *Tugboat—Mississippi River at St. Louis*, c. 1970

1. *Telegraph Poles*, 1932
2. *St. Louis Street Scene*, 1935
3. *John B. John*, 1950
4. *Black Hulled Boat*, 1930s
5. *Central Park*, late 1930s
6. *Union Square*, 1930s
7. *Road to the Sea*, 1930s
8. *Hell-Gate Bridge*, 1960s
9. *More Woods*, 1940
10. *In the Woods*, 1940
11. *Boy with Straw Hat*, 1940
12. *Kelse Drying Her Hair*, 1940
13. *New Jersey Landscape*, 1930s
14. *Riding in Connecticut*, 1945
15. *The Hunter*, late 1940s
16. *Girl with New Jersey Landscape*, early 1940s
17. *Model with Red Skirt*, 1940s
18. *Boats in Provincetown*, late 1940s
19. *Paris, Early Morning*, 1950s
20. *Cart on French Street*, late 1950s
21. *Chartres*, 1950s
22. *Small Town in France*, 1950s
23. *Cyclist, France*, 1950s
24. *Paris, the Seine with Tug*, 1960s
25. *Autumn Scene with Canal*, late 1950s
26. *The Tiber*, 1950s
27. *Church at Harbor Springs*, 1950s
28. *Two Horse Town*, late 1950s
29. *Dunes and Pine Trees*, 1956
30. *Michigan Moonlight*, early 1960s
31. *Self-Portrait with Pipe*, 1950s
32. *Portrait of Kelse*, 1950s
33. *Peggy Bacon at Home*, 1960s
34. *Notre Dame*, late 1950s
35. *Mont St. Michel*, late 1950s
36. *Yellow Still Life*, late 1960s
37. *Bouquet*, 1970
38. *Flowers in the Cottage*, early 1970s
39. *Kelse's Chair*, 1960s
40. *Michigan September*, 1960s
41. *Moonlight Sail*, early 1960s
42. *Girl in Green Shawl*, 1960s
43. *Girl in Yellow Chair*, early 1970s
44. *Portrait of Zeekie*, 1960s
45. *Portrait of Fred Conway*, 1960s
46. *North Wind*, 1970s
47. *Racing Sail Boats*, 1970s
48. *Harbor Nocturne*, 1960s
49. *Black Schooner*, 1960s
50. *Harbor Light*, 1960s
51. *Guanajuato*, early 1970s
52. *Mexico: Street and Cathedral in Distance*, early 1970s
53. *Bermuda*, early 1970s
54. *Beach with Pine Trees*, early 1970s
55. *Main Street, Harbor Springs*, 1960s
56. *Street Scene: Winter/Europe*, 1974
57. *From the Balcony*, early 1970s
58. *From the Bluff*, early 1970s
59. *From the Bluff with Boats*, early 1970s
60. *Lady in Lavender Blouse*, 1970s
61. *Talloires*, 1970s
62. *Yellow Trees and Monument*, mid 1970s
63. *Yellow Trees: Portugal*, mid 1970s
64. *Cathedral*, 1981

Wallace Herndon Smith, 1940s

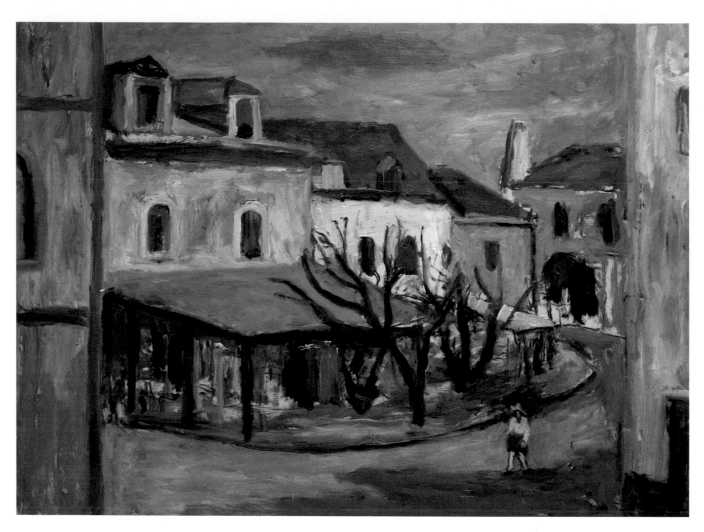

The Green Cafe, Portugal, 1970s oil on board, 27″ × 34″

Preface

This is the story of one American painter, heretofore almost unheralded, and of his singular life in art, his searches, personal failures, and successes as an artist. As a report on the more than five hundred works that remain in his studios in St. Louis and in Michigan, it is a record of one artist creating himself through his work. That, of course, is precisely an artist's fate: he works within the confines of art to reconstitute the raw materials of life, to effect a clarified and meaningful whole from otherwise scattered and seemingly meaningless fragments of experience. The result of his lifetime discipline, his works of art, reassure all of us that, through the ordering and intensifying powers of art, life gains deepest meaning.

Wallace (Wally) Herndon Smith today figures only as the faintest footnote in the conventional history of American art. He cannot be identified with an established school of art. He furnished little shock and therefore little entertainment to the larger art world. He nailed no manifestos to doors and never sought to batter down the fortresses of tradition. His conventional life offers the voyeur little opportunity to reaffirm the artist as rowdy, thug, wencher, mystic, charlatan, priest, drunkard, or genetic sport.

Yet, for more than fifty years, Wallace Herndon Smith painted almost daily, thought about paintings and about art, and tried with the means available to him to bring into alliance the talents he felt within himself, the requirements of daily life, and his perception of the puzzle of the art world.

Smith painted mostly in his native St. Louis but, strictly observed, he was never a Regionalist. He studied in France and appropriated both attitudes and skills associated with late nineteenth- and early twentieth-century French painting, but on balance he applied his vision and his paint through a predominantly American, even midwestern, sensibility.

Between World Wars I and II, he lived in New York where he was befriended by some of the major artists of the period: Thomas Hart Benton, Raphael Soyer, Walt Kuhn, Alexander Brook, Edward Hopper, and Peggy Bacon, among others.

He had successful (as measured by critical attention and by sales) exhibitions of his work in both Europe and America, yet he escaped celebrity and in 1942 chose to return to St. Louis. There, for almost fifty years, he masked his seriousness about painting with public tomfoolery.

In 1985 Wallace Smith's brother, Robert Brookings Smith; St. Louis business executive James A. Van Sant; and Director of the Missouri Botanical Garden Dr. Peter Raven determined to show Wallace's work to an audience larger than his St. Louis family and friends. They asked for guidance from the Academy for Educational Development and I, to my pleasure and gratitude, was assigned to the task of selecting and installing an exhibition of Smith's work for the Missouri Botanical Garden.

Another artist associated with St. Louis, Max Beckmann, has said of his own work as an artist:

I assume . . . that there are two worlds; the world of spiritual life and the world of political reality. Both are manifestations of life which may sometime coincide but are very different in principle. I must leave it to you to decide which is more important. . . . What I want to show in my work is the idea which hides itself behind so-called reality. . . . What helps me most in this task is the penetration of space. Height, width, and depth are the three phenomena which I must transfer into the picture, and thus to protect myself from the infinity of space.

After studying Smith's store of work and talking with him about his fifty years as a painter, I believe Smith could have uttered Beckmann's words if he had chosen to reveal his intimate feelings about art, if he had elected not to be flippant but to unfold for public view his drives and his obsessions as an artist.

His work is evidence of his lifelong pursuit of height, width, and depth, three phenomena which he, like Beckmann, has sought to transfer onto the plane to form the abstract surface of the picture, and thus to protect himself from the infinity of space. *Infinity of space:* isn't that chaos or void, the never-nothing-always that exceeds the limits of human fear? Or, on our daily scale, isn't that mortality? And isn't that, finally, the real subject of all art?

Isn't Wallace Smith, precisely because he painted almost alone and unseen, because he painted outside the media-celebrated art world, a specific instance of the universally acknowledged, if not stereotyped, artist? And, as artist, isn't his particular story the symbolic (or shared) story of everyone?

His work is subtle and modest in scale. Early on he selected a few themes, a few ideas, a few problems and subjects, and for the most part he stayed close to them. He painted still life compositions that include flowers (generally plastic because they hold still and do not fade). He composed numerous street scenes as if they were laid out on table top, yet other transmogrifications of the still life problems and attitudes. He painted a few portraits, figure studies, self-portraits. He painted boats and water.

These few themes—still lifes, land- and cityscapes, boats and water, a few figure and portrait paintings—occupied his time, controlled to a large degree his life. Grand subjects, salon or history paintings, ultimate psychological portraits and social comments never tempted him. Nor did he experiment very much with materials to find new ground, new expression. He stayed close to basic interests, to traditional and well-mapped ground in art where, over the years, he found his voice.

He tested that voice on "the Big Boys." After years of dreamy conversation with them in his mind and visits with their works in museums around the world, he claimed them as personal deities, as the gods and ghosts who, in his reveries about paintings, sanctified his studios in St. Louis and in Michigan. Rembrandt, El Greco, Matisse, Cézanne, Vuillard, and Goya: he might have described them to his family as "The Board of Directors of Art."

An artist's studio packages and extends his mental space, contains the territory in which he is safe to be himself and to work. Wally's studio walls are dotted with tacked and pasted-up reproductions of work by the Big Boys. They live in his studio amidst the equally casually strewn about pinned-to-the-wall fragments from magazines, notes to himself, lists long yellowed, broken fishing gear, bits of string saved from forgotten parcels, spent tubes of paint, labels from solvent bottles, floppy old sun hats, samples of French watercolor paper, plastic flowers off duty from the still life tables, and soiled smocks and paint rags.

Wally is not an abstract painter in style. But, ironically, as a traditional painter, in the act of making a painting, of understanding and explicating form, he called on the patterns of abstraction to enliven and describe space, to provide the substance for his personal symbology. Painting, as practiced by any serious artist, is first and always a means for clarifying and simplifying, and that means abstracting experience so as to understand it.

Wally's painterly contrariness fascinates me: precisely because he is a traditional painter, he wrestles with the abstract forces that give order to painting and, because those forces are never subsumed in narrative, the tradition of painting is well served.

New York, 1986

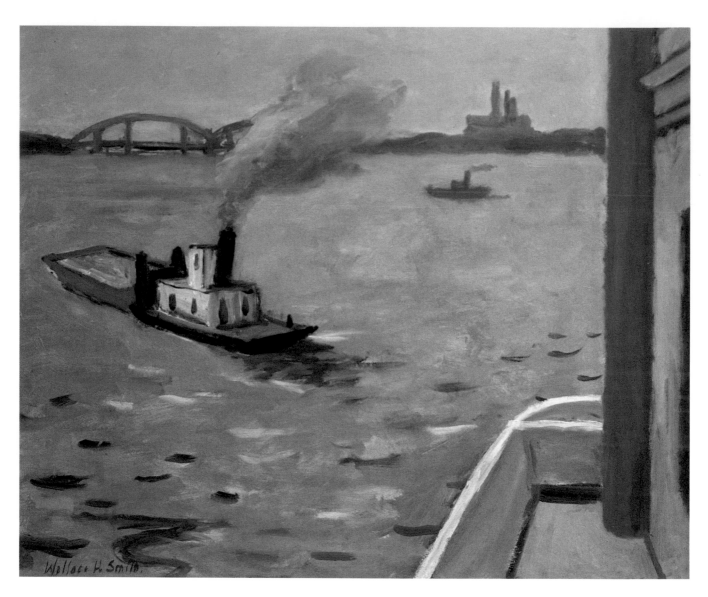

Tugboat—Mississippi River at St. Louis, c. 1970 oil on board, 25″ × 30″

Wallace Herndon Smith *Paintings*

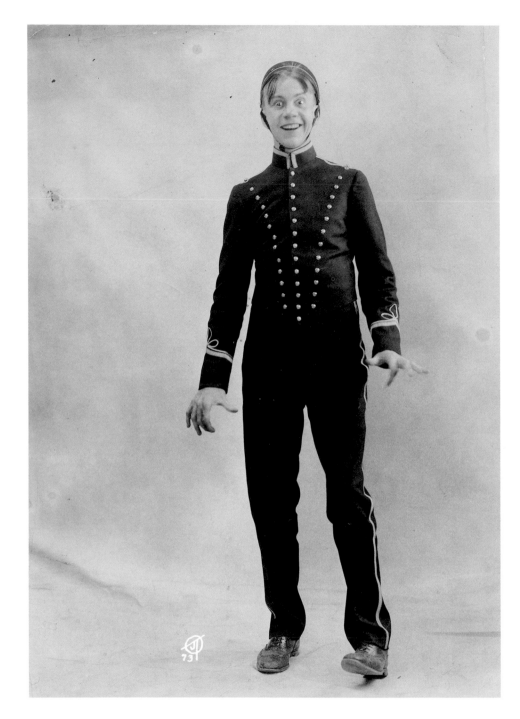

Wallace, a freshman at Princeton University, in a Triangle Club production

Family and Childhood

Wallace Herndon Smith was born May 9, 1901, at 5035 Westminster Place in the then very fashionable West End of St. Louis, Missouri. He was the oldest child of Lida Wallace and Jay Herndon Smith. Lida Wallace's mother, Mary Brookings, was the niece of the legendary American philanthropist and businessman, Robert S. Brookings, who, after making a fortune and systematically educating himself, founded the Brookings Institution and generously supported Washington University in St. Louis. Lida, herself steeped in the family values of hard work and probity, loved her husband and appreciated his affinity for the attitudes that sustained her own family.

Jay Herndon Smith, one of three sons, became, after a stunningly successful apprenticeship in investment firms in Chicago and St. Louis, a major broker and investment banker in St. Louis. Until his untimely death from a rheumatic heart disorder in 1928, Jay Herndon Smith accrued a sizeable fortune which he left to his family.

In St. Louis, Jay Herndon Smith won friends and loyal associates. He was affable and popular; he provided his colleagues and community with easy leadership and sound judgment without pontification. A loving father and husband, he deferred to his wife's prescriptions for childrearing but reserved for himself the right to spoil or indulge his children with gifts, travel, and attention.

The Smith children—Wallace Herndon, Robert Brookings, and Katharine Herndon—were born into a Victorian and affluent home dominated by the aura of family responsibility in which modes of behavior were assumed, urged, or prescribed according to unwritten but nonetheless understood rules. The children were cared for by nurses and nannies but Lida firmly orchestrated their routines, calendars, and education.

Despite the obtaining Victorian formality in the Smith home and the layer of domestic help between parent and child, the children felt themselves loved and special, believed that their parents were interested in them and understood their needs and feelings. Wallace, in part because of his seniority but also because of his innate impishness, led the pack in pranks and play.

The Smith boys went to grade school at the Smith Academy, which was a division of Washington University and, despite its name, without relationship to the family. When Smith Academy closed in 1916 there was immediate need to find a more appropriate and preferably distant place to continue the education of the young men. Wally's sister believes that Lida, tiring of young Wallace's continual argumentativeness and physical agitation, sent him to Lawrenceville in

Wallace at age three

Wallace and Robert in their playroom with a Christmas train set

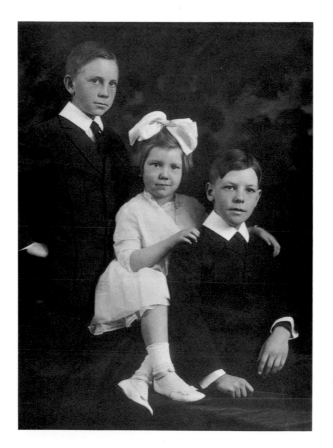

Wallace, Katharine, and Robert

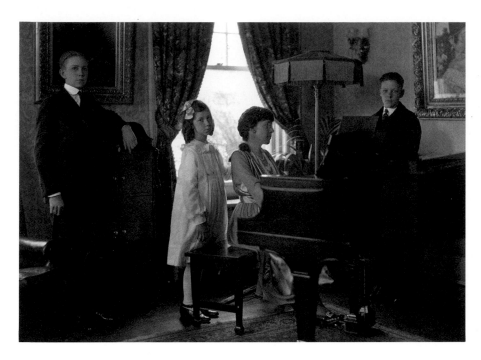

Wallace, Katharine, and Robert with their mother at the piano

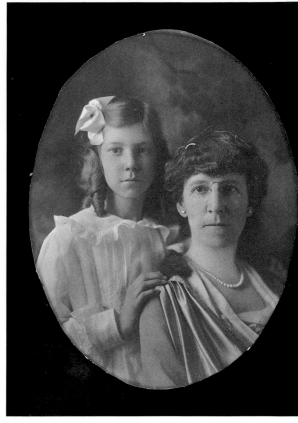

*Katharine ("Taffy") and
Lida Wallace Smith*

New Jersey in hopes of respite for herself, discipline for her elder son, and as the threshold to Princeton University.

Throughout his childhood, Wallace was a small and sickly boy, more given to pranks and mischief than to athletic prowess, and inclined to crankiness and argument more than to reading or other solitary activities. When he entered Lawrenceville in 1916 he was the smallest and youngest boy enrolled, a lad away from home with no distinction among his peers. He soon found, however, that his gifts for mimicry, for telling stories, and for entertaining other students and adults gained him attention and friendship.

In 1918, Robert followed Wallace to Lawrenceville. By 1919 both boys were very much a part of the school's rollicking life of games, pranks, and study; both were friendly and lively; neither exhibited above average interest in scholarship. Wally graduated from Lawrenceville in 1920 and Bob in 1922.

All three Smith children were more serious about play than about scholarship, but they took different paths by which to invest heavily their own energies in the risks and challenges that shaped them as individuals, that gave them pleasure, and that established each within the family. Katharine, the youngest, was soon and forever known as "Taffy." She enjoyed the feminine social graces of the period. She was warmhearted and outgoing by nature, appreciative of her brothers, eager for their attention and approval. Throughout her life she has won and kept friends through her gentle manners and her kindness. As the socially acceptable feminine pursuits claimed Taffy, boats won Bob's young heart. He

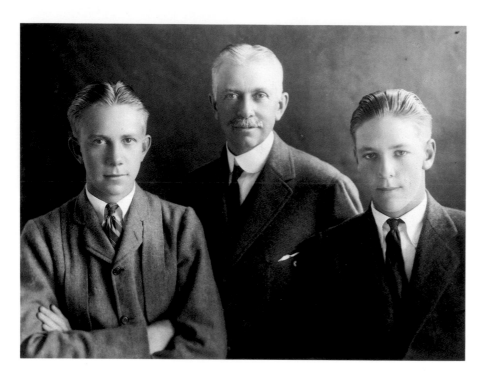

Wallace, Jay Herndon, and Robert, c. 1920

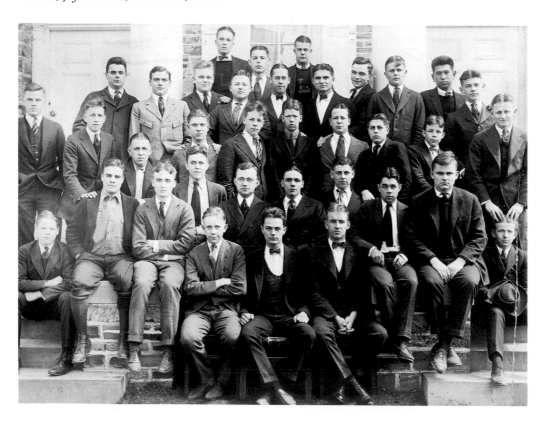

Lawrenceville School picture, c. 1920

soon devoted every possible minute and every shred of energy to fresh- and saltwater sailing, racing when possible and off-shore cruising with friends of similar mind. Wallace, having discovered early that his theatrical talents could be exercised to achieve applause and to amuse and charm family and peers, established himself as the entertainer of the family, a role that he was to fill for life.

Moreover, Wally's theatrical capers, whether performed on stage or off, provided him with a public persona that left him free, eventually, to paint away from curious and prying eyes.

In reflecting on the sources and drives of his paintings, Wallace Smith rarely draws upon incidents or residual feelings from childhood. Yet, he recalls with glee an incident at a summer camp in New Hampshire in 1914. There, he says, "I made a hero of myself." He recalls the moment of this acclaim with amusement. Lining along the edge of a dock with other boys, he was instructed by a camp official to dive into the lake and swim to another dock approximately a hundred yards in the distance. Wally admits, "I was scrawny and no good so I found my way to shallow water nearby and ran through the water to the other dock and got there first."

His underwater activity was well camouflaged by a great surface flailing of the arms and appropriate gasping of breath. It was a theatrical performance if not an athletic triumph. No matter. The young Wallace was delighted to win the prize and to win for himself even so brief a celebrity.

By the time that Wally entered Princeton University, two uncles, in the closeness of the extended Smith family, had influenced him measurably. If he absorbed his father's affability and social grace, he appropriated aspects of Uncle Bill's (Jay Herndon Smith's brother) flamboyant playboy-about-the-world style and Great Uncle Robert's assurance and faith in the individual's ability to shape life and effect change. These men, possessing seemingly limitless stores of energy and imagination, pursued different goals and each in his own way proved a charm to Wally's life.

Wally entered Princeton University in 1920. He kept the somber requirements of regular classes enough in mind to remain in school but learning for its own sake held no allure for the lively and outgoing young man. He had come to Princeton for the social experience, for an extension of the fun and games that had occupied his childhood, and for a wider audience for his talents as an entertainer. He joined the campus theatrical club, the Triangle Club, and made it the center of his college life.

Soon his interests focused almost exclusively on the Triangle Club. He wrote, he sang, he tossed off jokes as the accepted leader of the group. With full support of his family, he took a semester's leave from the mundane studies that limited his involvement in the theater and went to England to do research in preparation for writing "Drake's Drum," a musical comedy he co-authored and put forward for the Triangle Club's gala performance of 1923.

Through the production of "Drake's Drum," Wally indeed achieved fame and success at Princeton. His hometown newspaper wrote, under the headline, "St. Louis Collegian Writes Play for Princeton Players":

Wallace H. Smith, son of Mr. and Mrs. J. Herndon Smith of 6500 Ellenwood Avenue, a senior at Princeton University, has been elected president of the Princeton Triangle Club. . . . Smith has been starring for three years in the cast of the annual Triangle Club play and has written many of his own lines and limericks. He is the author of "Drake's Drum," the play chosen by the club for 1923, and plays the leading role in the production which is now being rehearsed at Princeton. The play is a satire on English naval history, and many of the scenes are laid aboard ship.[1]

1. *St. Louis Post Dispatch*, October 28, 1923.

His family expected him to continue his interest in the theater and, furthering the pleasures of New York theater and cafe society as introduced by Uncle Billy, to take to the stage and to raise hell as a playboy.

When Flo Ziegfield, after seeing "Drake's Drum," offered Wally a role in his famed Follies, the Smith family was confused and surprised in equal measure when Wally turned down the opportunity to build his life upon the professional stage. They had assumed that their talented and much admired son and brother—the one so successful in the Triangle Club, the one so loudly applauded by an increasingly larger public, the one whose yearly capers on the collegiate board had brought them to the theater to applaud and cheer alongside strangers—would indeed pursue his fate in the theater.

No one recalls why exactly Wally decided against the theater, but all agree he was fully, if warily, supported in his decision by parents and brother and sister. While his father would in later years occasionally express his opinion that Wally might have made a mistake, he was content to let Wally shape his own life and select his own audience. Wally was adored and encouraged in any action or intent; he was deprived thus of any possibility or necessity to rebel.

If a young man cannot rebel, at least he can startle. With the aplomb of a princely stage entrance, with perfect timing and fine diction, Wally announced his intention to become an architect. Family jaws dropped. It was good theater; Wally bowed to family applause.

He enrolled in the graduate program in architecture at Princeton University in the spring term of 1925. His undergraduate habits, however, followed him to the more rigorous and demanding curriculum. He played pranks and entertained his fellow students with songs and jokes. He clowned about wearing the then-required academic robes to dinner. He was disruptive and seemingly uninterested in a serious study of architecture. Finally, following a joke that involved placing whiskey bottles visibly in a graveyard, the dean summoned Jay Herndon Smith and expelled Wallace.

Wally appeared to those who met him to be a preeminently attractive young man, full of jokes and life, rich and socially presentable. He was often a guest at parties, dances, and outings designed to bring young men and women together so that "good" marriages between young people of similar background, wealth, and promise would ensue. On the dance floors and at the buffet tables rather than at the drafting table of the architecture department, Wally devised and followed his own curriculum.

At a dance in Montclair, New Jersey, a suburb of New York City, Wally met Mary Alice Kelsey. He called her Kelse, the nickname that would become her identity, and teased her and made jokes but his heart had been claimed, a sobering experience for the playboy from St. Louis.

Kelse was by all accounts a raving beauty, dark haired, lithe, and charming. One of five daughters, she learned early how to charm her parents, her teachers, and other young people. She had an easy manner, somewhere between flirtatiousness and audacious impertinence, that delighted both those her own age and her elders. Her banner of pleasure was neither as vivid nor waved as enthusiastically as Wally's but, for her family, she was less decorous than they thought obligatory for a young woman of good breeding.

Kelse found Wally's irreverence, his wit, his liveliness very attractive but her family, rooted in New England's values, strict in their rearing of daughters, and stern in their Calvinist view of the good life, the proper life, considered Wally frivolous, flighty, and unsuitable as a husband.

After a courtship of five years, discouraged on all sides, Wallace Herndon Smith and Mary Alice Kelsey were married April 10, 1926, at the Kelsey home, 21 van Vleck Street, Montclair, New Jersey. Archibald Black, a very Scottish minister, officiated. The eminent great uncle, Robert S. Brookings, as well as Jay and Lida Wallace Smith attended. Wally's brother Bob was best man and Kelse's sisters attended the bride.

Kelse's Presbyterian cousin and her husband gave a party for scores of guests. The newlyweds, of strictly modern cast, found the party stuffy and dull. The groom and his youngblade friends, however, overcame handily the official sanction against booze and, as the party progressed and the young people found frequent occasion to make use of the planted stores of liquor around the fringes of the party, even Wally and Kelse recognized improvement in the event.

Wally and Kelse left Montclair for a honeymoon at The Homestead in Hot Springs, Virginia. After ten days in the sweet Virginia spring, the newly married Smiths returned to St. Louis in late April of 1926.

Lida Smith, efficiently acting on her own notions about proper housing for newlyweds in St. Louis, had rented an apartment for them near Washington University, on the south side of Forsyth Boulevard by Our Lady of Lourdes Catholic Church. The apartment fell far short of Kelse's expectations. The summer grew hot and Kelse's unairconditioned patience wore thin. Children in the church schoolyard maintained an almost continual level of unbearable noise so that the apartment was suspended, in Kelse's memory, between the street din and the stifling heat of a St. Louis summer.

Meanwhile, Wallace enrolled in the graduate program in architecture at Washington University. Monsieur Ferrand, of the firm Ferrand and Fitch, was dean of architecture at that time. In Dean Ferrand's classes, Wallace sat on the front row and applauded loudly. In secret, Wally held the dean in disdain, commenting only that his firm had done "a few little houses."

Dean Ferrand, however, was aware of the significance of Wallace's Uncle Robert to the university. Uncle Robert, after all, was chairman of the Board of Trustees at that time. Whether the hapless professor regarded Wallace's applause and expression of admiration in class as sincere or recognized it as the display of sophomorish cynicism that it was, he granted excellent grades to Wally.

Despite the apparent success of his academic pursuit of architecture, Wally was bored with the endless exercises, the tedious lectures, the details that seemed to him trivial. While he knew that he liked drawing and architecture more than he liked studying to enter the gentlemanly profession, knew that he liked creating from imagination more than he liked analyzing the needs of other people, knew that he liked the free flow of watercolor more than he liked the tight requirements of rendering, he did not believe that architecture promised either the fun or the audience that he required.

Kelse had opened Wally's heart to a seriousness that had not colored his life before their marriage. Still, he craved a freedom and excitement he could not quite name, he wanted to dedicate himself to high purpose. He wanted to find significance in life and, acting upon such seriousness, win applause from Kelse.

Painting, for him, promised that seriousness; it seemed appropriate in the shadows of Uncle Robert and Uncle Billy. It seemed to provide a means for synthesizing all the things Wally desired for himself and for Kelse.

He confided to Kelse. He wanted to be a painter.

It suited her perfectly.

Wally and Kelse decided to spend a summer in Provincetown, Massachusetts, where Wally planned to study painting. Marie Taylor, another artist from St. Louis, was there at the same time and both she and Wally enrolled in Jerry Farnsworth's classes.

Marie Taylor, who was to grow in reputation as a sculptor and painter with exhibitions at the Betty Parsons Gallery in New York over several decades, recalls Farnsworth's authoritarianism and his insistence on his students painting only with a palette knife. By removing the brush from the process of painting, Farnsworth intended to compel his students to lay out larger planes of subject

Wallace Herndon Smith

matter, to simplify areas, to see clearly the color relationships inherent in a work and to think freshly about the composition and internal spaces of a painting. Instead, his doctrine became a gimmick, a mere trick of the trade, that soon bored Wally.

But Wally was not discouraged. He returned with Kelse to St. Louis with his appetite for painting growing keener and his interest in architecture growing dimmer.

Kelse had tried to make the apartment comfortable and had tried to enjoy the family's list of approved pleasures and purposes. But lively Kelse's view of the world could not be contained in St. Louis or, for that matter at that time, in the United States. She, like Wally, wanted intellectual stimulation and cultural growth not available in St. Louis. Both young people looked, as did many of their generation, to Paris for fulfillment, excitement, and tutelage.

After her first year at Vassar College, Kelse spent a year at the University of Grenoble where she studied French language and literature. She fell in love with France. She never doubted that France held the secret for Wally to all things related to art.

In the period between 1921 and 1927, the museums in the United States showed the work of European artists with far more frequency and interest than they showed the work of American artists. Art connoisseurs, both amateur and professional, had a point of view still shaped largely by European standards of taste. While inexorably the public interest in art had begun to creep in the direction of late nineteenth-century and early twentieth-century art as exemplified in impressionism, this was by no means an indication of openness to the self-conscious modernism embraced by many artists of the period. In 1921, the Metropolitan Museum showed the post impressionists and, when the important Barnes collection opened two years later, still more European artists, notably Cézanne and Renoir, were given preeminence. Wallace Smith's artistic adolescence occurred in the decade following the 1913 International Exhibition of Modern Art, known as the Armory Show, in which the shock created by that show was assuaged and business went on as usual. Americans weighed their culture in relationship to Europe and they considered art in this process. Wally, too, looked to Europe for art.

When Wally considered the means by which he could become an artist, he naturally inclined, as other aspiring American artists before him had, toward Paris. But he had not gained enough courage to announce himself as a would-be painter. He had set himself up to practice architecture. What would he do to escape both architecure and the confines of St. Louis?

In January 1927, Wally and Kelse sailed for France where they planned to live while Wally studied architecture and Kelse continued to perfect her speaking and reading French. William Merritt Chase had said, "I'd rather go to Europe than to heaven."[2] The young Smiths, settling in to their trans-Atlantic journey, might have uttered the same passion.

Mary Alice Kelsey Smith

2. This is quoted in the *Indianapolis Star*, January 14, 1899, and in Wilbur D. Peat, Chase Centennial Exhibition: A Catalogue for the John Herron Art Museum, Indianapolis, Indiana, 1949.

A French village visited by the Smiths while living in Paris, 1927

European Influence
and American Regionalism

Paris, 1927-1928

Wallace and Kelse looked upon their time in France as an extension
of the holiday mood that they were creating for themselves and for
their marriage. Through the romance of living in Paris, they longed
to find a new freedom and a direction that would ensure excitement in their life
together.

Wally, increasingly drawn to painting as a profession but still too timid to
abandon architecture, set about studying with George Gromont who, in his
estimation, was "the greatest designer of bridges in the world." Soon, however,
he became bored again with the necessity of dwelling on details that he considered
trivial. He determined to make his escape from architecture, to turn his intelligence
and energy to painting.

Meanwhile, the Smith's only child, Jay, was born in the American Hospital in
Paris on September 11, 1927. While Jay's presence necessarily required most of
Kelse's time and attention, she nonetheless maintained her watch over Wally.
Would their son, this new responsibility, Wally and Kelse wondered, prevent
Wally from studying painting?

With Kelse's approval, Wally enrolled in the Ecole des Beaux-Arts through the
influence of an American friend who assured officials of the prestigious institution
that Wally was "very proficient in water color." In truth, he had acquired the
requisite facility in the difficult medium through his architectural studies but,
rather than using watercolor as a freeflowing medium to open the imagination
to unexpected dimensions and intensities of expression, he handled it at that time
as tinting or coloring washes to be precisely laid over meticulous architectural
drawings.

Once accepted in the Ecole des Beaux-Arts, he was set on a course of study
which led him soon to the conclusion that the Ecole was overrated, that it could
not provide challenge suitable for postgraduate study, that at best it might parallel
the last two years of a mildly rigorous collegiate program in art in the United
States. Moreover, while the other students were younger and puppyishly playing
at rough and tumble Bohemianism, Wally husbanded his Princetonian seniority
as tidily as he persisted in his architectural renderings in watercolor.

The other students, predominately French, hazed the openly disdainful
American student by setting fires under the stool on which he sat to work in the
studio. This, Wally thought, was not the path he would follow toward becoming
an artist.

Jay Smith, 1929

27

Before he found antidote to his discomfort in the Ecole, he was summoned home by the sudden death of his father. Wally, Kelse, and their infant son returned to the United States. In the brief time in Paris, Wally had not found his way into painting. Exactly a year after their expatriation, Paris, by misfortune, was being taken away and with it their dreams for their future.

1928: Return to St. Louis

Wally and Kelse returned with Jay to St. Louis in January 1928. Wally had not graduated from the architectural program at Washington University, but through family friendships he found haven in the firm run by Louis La Beaume, an architect who painted and who, indeed, was so seriously concerned with painting and the fine arts that he served as a trustee and chairman of the board of trustees of the St. Louis Art Museum for many years. Under the parental eye of Louis La Beaume and the encouragement of his senior architectural designers, Wally designed several houses over the next few years: three for family members, including his mother's residence in the St. Louis Country Club grounds; an elegantly styled variation on a French country house for himself and Kelse; and a restrained, somewhat more delicate version of the French country house for his sister, Taffy. He also designed a hospital that was never built.

As he worked at being an architect, Wally was encouraged to paint by Louis La Beaume. He also fulfilled family expectations by attending social functions and telling amusing stories. He stepped easily into the role he had earlier tailored for himself: he was an entertainer.

By 1929, despite his increasingly active social life, Wally was painting continually and, in his heart, daring to think of himself as a painter. Who, he asked himself, had been painters? He and Kelse, nostalgic for Paris and for their automobile jaunts it the French countryside and the museums of Europe, talked about painters, about paintings they had liked, about what made a painter good. Wally began to talk to Kelse about the old masters and a few of the modernists: Rembrandt, Renoir, Goya, Modigliani, Cézanne, El Greco, Matisse, Vuillard, or Gauguin were the names that tumbled one over the next through their conversations about art.

They compared and refined their attitudes about painting; they encouraged one another to recall passages in paintings and to describe them. Wally and Kelse longed to see the paintings they had known in France.

But, like most students undertaking the study of painting in the twenties and thirties in the United States, Wally looked, too, to the American painters of the day for guidance.

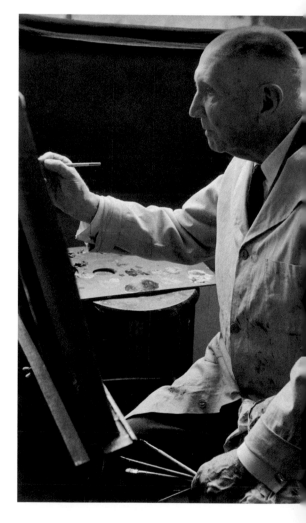

Louis LaBeaume painting in St. Louis studio

House in Ladue, Missouri, designed by Wallace Herndon Smith in 1930

He rehearsed his knowledge of the Armory Show and, in his conversations with Kelse and with his colleagues in La Beaume's office, he speculated on the meaning of modernism in American art. Mindful that he had entered the twentieth century in its infancy, Wally sought the bridge between his own era and that of the past: how did these modernist artists follow the masters, how could an aspiring young American artist understand John Sloan, Marsden Hartley, Maurice Prendergast, Robert Henri, George Bellows, Georgia O'Keefe, or Walt Kuhn?

As he struggled with the bombarding sensations that surrounded the new art, Wally tried to measure his talent, to test his skill, to find certainty for himself as a painter. He turned during this period in his life to the American Regionalists, to Grant Wood and Thomas Hart Benton and John S. Curry.

In this period, Wally met Joe Jones, a St. Louis artist who supported himself by painting houses, among them the houses that Wally had designed. The two men soon discovered their common interest and began to paint together, often setting easels and materials in parks around the city. Both men were aware of the Regionalists; both wanted something more demanding for themselves in painting. They experimented in their own work with the simplified and dramatic forms of Regionalism but criticized their efforts in the light of their exemplars.

In later years, Wally would resist any comparison with the Regionalists and claim that he had rejected them out of hand and eye. His early paintings, however, are evidence of a Regionalist interest on his part that influenced his infancy as an artist.

Before he went to France to study and to look at great European art, before he analyzed French impressionism, and well before he fretted over polarities of art styles and theories, the distinctions between abstraction and naturalism, he embraced happily his own highly modified version of Regionalism. Working close to the Regionalist style and palette, he gained a degree of freedom from strict academic drawing. His particular style of Regionalism allowed him to use the drawing skills of architecture that he had acquired to organize masses as if they were buildings and, indeed, to use buildings as plane and mass in a painting. Having thus established the essential underlying form of a painting, he learned that he could explore the emotional content or evocative power by playing darker and lighter colors against each other, by setting tone of paint against tone of paint and by using shadows and light to enhance the drama of a scene.

The Regionalists, like Wally and Joe Jones, claimed middle America as home and ostentatiously eschewed the fancy talk and Europeanized attitudes that held the attention of large segments of the small American public that appreciated art at this time. Wally liked the toughness of mind and language that marked the Regionalists; he liked their freedom from the convention and discipline that seemed so boring and useless to him.

During the period, whether he applied his eye and hand to the scenes of city or countryside, his work was strongly drawn, simplified, and boldly painted with strongly contrasting but somber tones in a style influenced by the Regionalist painters.

Some of the visual ideas that he developed during these early journeys into painting, some of the little idiomatic treatments of form, were to remain potent and characteristic forces in his work throughout his life. In these early paintings, for example, he began to use architectural elements, contrasts between light and dark, and simplified planes as the basic elements of his compositions.

But doctrinaire Regionalism cramped Wally. He felt unable to use its strictures to lay hold of painting as he believed it to be defined by the greatest artists. As he and Kelse talked, they decided to leave St. Louis to place themselves in the major arena of art at the time. Reckoning from the art publications and from conversations in the St. Louis Art Museum and Louis La Beaume's office, they would move to New York.

In 1930, Wally received the Halsey C. Ives prize for a watercolor landscape which, to the young artist's joy, was shown at the American Water Color Society's winter show in New York. What better sign did he need, Wally asked Kelse. He had won a prize; he was recognized as an artist; he was ready for a bigger stage.

Triumph begets triumph, Wally assured Kelse. Moreover, as if to prove his point, Meyric R. Rogers, director of the St. Louis Art Museum, selected one of Wally's paintings, *St. Louis Street Scene,* for inclusion in the museum's annual juried exhibition. The painting won honorable mention. Wally was ecstatic; Kelse sang his praises; and Louis La Beaume, Wally's mentor and friend, corroborated Wally's reaction.

How many signs did a fellow need?

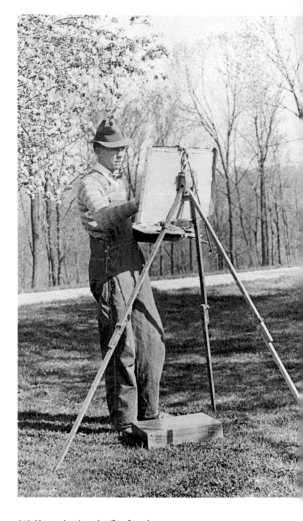

Wally painting in St. Louis, late 1920s

New York, 1932–1942

By 1932, after four years in architectural practice in St. Louis, Wally decided to pursue the profession of painting with all stops out. He and Kelse moved to New York confident that he could win a place for himself in American art. New York City, they knew, was the center of art in the United States and a great deal was afoot there, reputations were being made, artists were meeting each other and talking and learning from one another. They longed for the community of other artists. In lieu of Paris, New York would suffice.

During the 1930s while the country was in the grip of economic depression and social turmoil, Wally and Kelse lived in New York in a fashionable style. Their homelife, as compared with the life led by most of the painters of the period, was luxurious. Most painters were by definition—if not by religion—poor, desperately serving their art gods in the garrets and lofts of the lower Manhattan side streets.

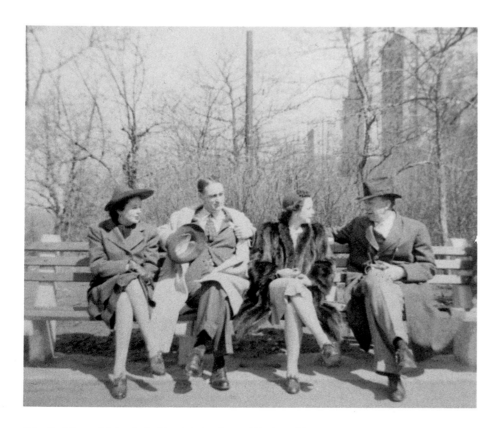

The Smiths and friends in New York's Central Park, 1930s

The romantic conception of the painter condemned him to poverty. Rejected by society and without financial support, the artist continued to work while knowing that no one understood his work (necessarily too advanced) and knowing, too, that there was no market among the philistines for the pure, sweet voice of reason and beauty that informed his work. This romantic role for painters, growing in popularity and familiarity in the public mind since the Industrial Revolution, rose like a cloud of noxious gas over the art world of New York in the 1920s and 1930s and, to some degree, remains.

The myth became a set piece. All the artists knew the litany: for instance, anything that sells cannot be a work of art; poverty is the seedbed for art; artists are born to suffer and any failure to do so is a moral mark against their talent and a challenge to their very claim to be an artist. These attitudes, flourishing in the Depression years in New York along with often markedly leftist political views, were hardly congenial to the Smiths.

In this milieu, Wally went knocking on the doors of inhospitable dealers and, as he counted his bruises, he grew increasingly ambivalent about his identity as an artist and about his identity within the established art world. He took little comfort in learning that *St. Louis Street Scene,* after its inclusion in the annual exhibition at the St. Louis Art Museum, was shown in 1932 at the Art Institute of Chicago. No one in New York seemed to notice.

During the 1930s, Wally often attempted to be a part of the New York art scene. He visited the Lotus Club, whose members were successful men from all of the arts, where he saw the pictures of painter-members and decided that it was not the place for him. He felt no more comfortable, however, with the less accepted, more advanced artists of Fourteenth Street.

He and Kelse were eventually close to the satirical artist-writer, Peggy Bacon, and her husband, Alexander Brook, with whom Wally studied for a while. But, on balance, Wally made few lasting friendships from among the artists of the decade.

Several of the artists known to the art world of the thirties and now fully recognized as major American painters—notably Walt Kuhn and Edward Hopper—found Wally's work engaging, promising, accomplished. Each, in several instances, encouraged Wally to paint, to continue to work in his own emerging style and to exhibit his work. Each, by doing so, took Wally's work seriously and recognized him as a fellow artist. But even so, he remained aloof from the social life of artists in New York. He found no membership in a community of artists in New York; he had found none in Paris. He was, he felt, an outsider.

Kelse recalls, "We were neither fish nor fowl. We were not with the arty group, nor were we accepted by the business group. Wally would take the subway every day from our apartment on the Upper East Side down to Fourteenth Street where he would work." In this division of space and time, Wally bisected also his working life and himself.

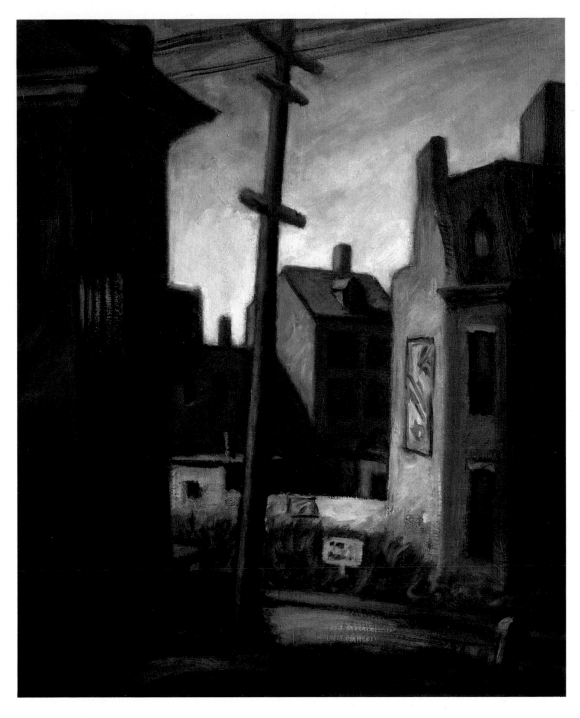

1. *Telegraph Poles*, 1932 oil on canvas, 29″ × 21″

Wally was financially independent. Moreover, he was hardly a man to be identified with working men. He had enjoyed the best education money could buy; he had been brought up safe from poverty and want; he had been swaddled in privilege and opportunity from birth. His days at Princeton had further persuaded him to his role as gentleman. Most visibly he had achieved a high gloss as an entertaining playboy, but despite his efforts, he had not achieved the identity and status of a painter.

Having given himself to art, having adopted the ideas current about the necessity and nature of art in civilization, he now faced the impossible task of finding a niche for himself in the art world in New York. Not a rebel, either in society or in painting, he clung tenaciously to his commitment to tradition. Increasingly he looked to France for corroboration of his ideas and images and not to the muscular, sometimes rude, art world of New York.

He was neither psychologically nor socially cut from the same cloth as the artists who shaped the New York art world of the period. He observed artists at work and attended their conversations in bars and restaurants. By birth and by conditioning, however, he was a prisoner of the American middlewestern upper class which fabricated its prison of Victorian and Protestant strictures against sin and for work. Their psychological prison was as limiting and painful as the poverty and deprivation mythically associated with artists and their Bohemian lives in the United States. Wally belonged nowhere; he brooded over his lack of professional recognition as well as his failure to find membership in a community of artists.

Between the stockmarket crash in 1929 and America's engagement in the Second World War, many American artists thrived under the wing of the Federal Arts Project, a part of the New Deal. Artists as diverse as Rockwell Kent, associated with Ashcan realism; Stuart Davis, Stanton McDonald Wright, and Joseph Stella, who supported various forms of abstractions and cubism; and Reginald Marsh and other social realists, worked for the WPA. Artists who drew deeply from the imagination as they treated realism and surrealism—men like Jack Levine, Peter Bloom, Paul Cadmus, and Morris Graves—as well as the forerunners of abstract expressionism—Arshile Gorky, Jack Tworkov, Willem de Kooning, Philip Guston, and David Smith—all owed their subsistence at this time to the Federal Arts Project.[1]

Wally took superficial interest in some of the artists supported by the Federal Arts Project, but the project itself held little interest for him politically or aesthetically. His ideas about art, tempered slightly by Regionalism, remained largely the result of his time in France. He considered himself apolitical, a pure artist who, by virtue of talent, should have the privileges and acclaim necessary to further his work. At this time, Wally simplistically divided artists into those who drifted wrongheadedly into abstractionism and those who honored tradition. Without coming to grips fully with the nuances of either pole, he chose certain painters above others and opened his sensibilities only to the lessons that they might teach him.

1. See Richard D. McKenzie, *The New Deal for Artists* (New York: 1973); William Stott, *Documentary Expression and Thirties America* (New York: Oxford University Press, 1973).

On the second day that he and Kelse were in New York, they were invited to join friends for a spaghetti dinner and to meet Walt Kuhn, the much-admired painter who had contributed singularly to the public awareness of the Armory Show in 1913. Kuhn, in Wally's view, was a god, an established artist. Moreover, some months earlier Kelse had met Kuhn in St. Louis at the opening of his exhibition at the museum. Kelse, one of the most attractive women in St. Louis at the time, easily caught Kuhn's attention. "My husband," she told him, "is also a painter." When Kuhn learned that the Smiths were moving to New York, he offered to take a look at Wally's work and to advise him on "making it in the art world."

When Walt Kuhn swaggered into Wally's life, he acknowledged Wally's talent while he sought to reorganize Wally to meet the requirements of the art world. Wally, pleased by Kuhn's attention, listened carefully to the older artist's views. Uptown—Wally's world—was enemy territory for Kuhn. Uptown, in Kuhn's view, was occupied by the Philistines, the ruling *haves* who, in his belief, spent most of their time plotting further humiliation and deprivation for the *havenots*. Especially their betters. Especially the artists.

Walt Kuhn, costumed as artist and working man, joined the Smiths and their friends for dinner. His guard was up and his defenses bristled as hostility and offense. While biting the hands of his dinner hosts, Kuhn hoped to profit by association with the rich.

After a few drinks, Kuhn blasted Wally's position and cut quickly to the central issue, his talent and his desire to be an artist. "Listen to me, you applecheeked countryclub boy," urged Kuhn, "I can make you an artist. Study with me. I'll teach you how to paint."

Wally, at once flattered by the attention of a celebrated artist and frightened by the man's attack, withdrew in mutterings of humility. Kuhn forged ahead. "You'll never be a painter, despite your talent," he began to yell. "You'll just be a silly country boy come to town. Give up your fancy uptown life. Live! Live!"

Wally smiled. "Sure," he said. Kelse sniffed trouble brewing and withdrew into silence.

Kuhn continued. "You must have affairs; models expect it. You must show that you are a man if you want to be recognized as a painter. You need to drink and raise a little hell, to be seen with artists, to live."

Kuhn settled his attention then on the flow of free whiskey and passed the remainder of the evening self-absorbed, sullen, and drunkenly hostile. When thoroughly drunk, he ambled off, leaving the Smiths smarting under his sting, to return uptown to their comfortable home.

Kelse was frightened. What would happen? Would Wally, so eager to be a painter, so desperate to be recognized, so willing to serve art in all its requirements, be moved toward the artist's rebellion prescribed by Walt Kuhn?

The Smiths talked long into the night. Each tried to quiet the other's fears. Each felt threatened and attacked by Kuhn's words, which, timidly, they rejected.

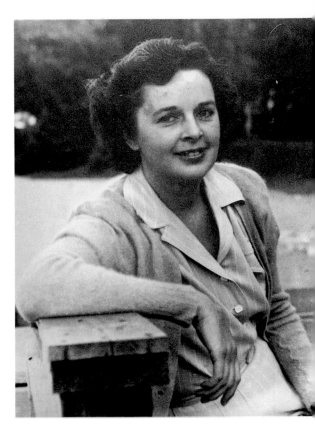

Kelse at Harbor Springs, late 1930s

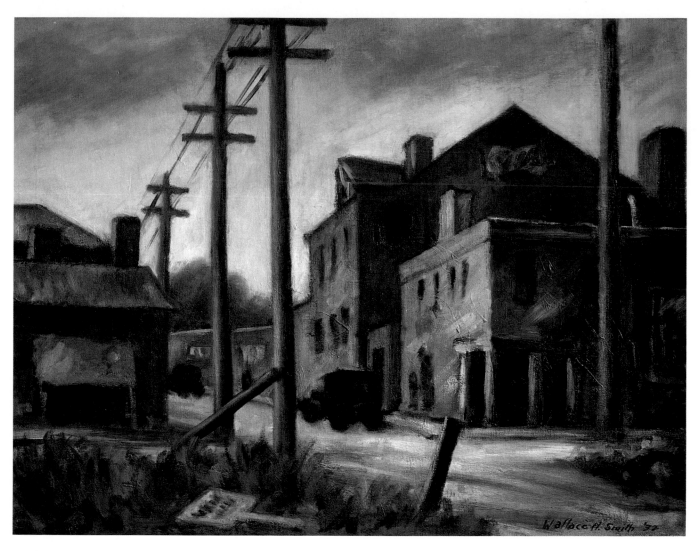

2. *St. Louis Street Scene*, 1935 oil on canvas, 25″ × 30″

Meanwhile, Edward Hopper, whose work reflected an affinity for Regionalism, won Wally's early and lasting admiration. Hopper's paintings (not Kuhn's) stimulated Wally to question his own work and to consider the criteria by which his paintings might have been recognized by the painters he revered.

Hopper was born in 1882 in Nyack, near New York City. He studied with Robert Henri in the early years of the twentieth century and, like Wally, went to Paris several times following that. Like many artists of his day, he went often to Gloucester to paint. He traveled along the Maine coast and explored Cape Cod in search of subject matter, light, and the vision of isolation that drew him to these seaside regions. Though Hopper had clear visual and aesthetic roots in the Ashcan School, he consistently employed more visible architectonic means of composition

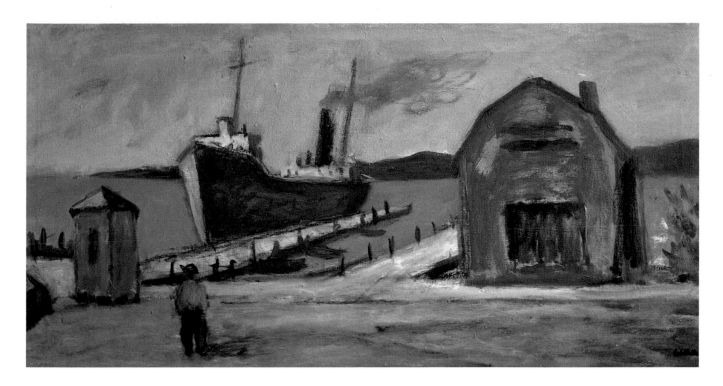

3. *John B. John*, 1950 oil on canvas, 18″ × 36″

by building his paintings of angles, rhythmically related to strong horizontal lines, by using masses of architecture against equally assertive masses of land, sea, or sky. These subjects, painted to celebrate light and to suspend depicted people in loneliness, were the subjects that gripped Wally's imagination, too.

Hopper was contemporary with two other artists admired by Wally, Reginald Marsh and Raphael Soyer, but Hopper differed from those two social realists who proclaimed the attitudes of the Ashcan School.

Hopper usually elected scenes devoid of people or action while both Soyer and Marsh painted as if people, their major subject matter, were always frozen in action. Instead, Hopper found poetry in sunlight on the side of a house or in a strange electric light glowing in lonely diners at night. Light, in whatever form, became the essential ingredient in both Hopper's watercolors and his oil paintings. He thought of light as illumination but also as the substance of mystery and the shaper of the often lonely or quiet effect which characterized his paintings.

Wally fell under the spell of Hopper's paintings. Those quiet and sometimes sad paintings gave form to some of the feelings that swirled inside him.

Wally was brother to all other artists, past and present: he wanted to find order in personal vision that would assign order to deepest feeling. As he studied Hopper's work, he lightened his palette; he sharpened the edges of architecture in his paintings; he emphasized the underlying compositional elements in his work. Order. Form. Those were Hopper's instruments. Wally claimed them, too.

Wally, c. 1932, in the New York apartment

Subjects that would forever find place and attention in his painting, architecture and still life compositions, allowed Wally to concentrate on form and order. He won attention from the artists he admired most. Hopper himself, not knowing Wally at the time, and certainly not knowing that Wally considered him a demigod of painting, recommended Wally for a prize in Philadelphia. Hopper was overruled by other members of the jury. Nonetheless, Hopper's approval touched Wally deeply when he learned of it, and it became, over long years of solitary work, a fond recollection, an accolade that was sweet even though it was not publicly realized.

Wally, still uncertain of his own ability, wanted instruction, wanted a master to lead him through apprenticeship to his own masterpiece and, with that, to certain and visible status as an artist. He felt himself to be still a student, greedy for learning, energetic and resourceful but undisciplined and lacking clear direction toward the estate of painting as he imagined it ruled by the Big Boys.

He decided to enroll in Thomas Hart Benton's class of twelve students at the Art Students League. Jackson Pollock, too, entered Benton's class. But neither

Pollock nor Smith liked Benton. They disliked his strutting ego and macho vulgarity, but in later years, Pollock was to demonstrate similar behavior. At the time the young men were students, however, Smith and Pollock hated equally Benton's verbal abuse of his students, his taunting and belittling them, pressing them to heated and angry frustration and then, laughing, leaving them to smolder while they worked. This psychological torture, Benton insisted, worked up their passion (or at least their spleens) and set them to turning that energy into the energy and form of art.

This was not Wally's style. He did not submit as Benton required but, rather, became increasingly aloof, increasingly and elegantly disdainful of the midwestern master.

Pollock, equally proud, joined Wally in withdrawal, in working alone, silently and grimly. One day, as Wally was to recall frequently in later years, Pollock said, "Listen, Smitty, we should stick together. Neither of us can draw."

After taking the art world by storm following the Second World War, Pollock would insist that stubborn resistance to Benton's teaching had led him to his sensational break with apparent tradition in painting. For his part, Benton took clear aim at his former student when he wrote: "Modern Art became, especially in its American derivations, a simple smearing and pouring of material, good for nothing but to release neurotic tensions. Here, finally, it became like a bowel movement or a vomiting spell."[2]

2. Thomas Hart Benton, *An American in Art, a Professional and Technical Autobiography,* p.186 (Kansas City, Mo.: University of Kansas Press, 1969).

As Wally worked to find his voice and niche in painting, he, like Pollock, set the pace for his future development as an artist. Several of his paintings of this period, born of visits and recollections of Missouri, show strong influence from Thomas Hart Benton and other Regionalists in the sharp contrasts between light and dark, the silhouette treatment of trees, and the curvaceous landscape. City scenes reflect the influence of the Regionalists, as well as "The Eight" and Edward Hopper. Indisputably American, even midwestern, Wally's paintings from the thirties provided ground for him to hypothesize about the nature of painting.

He might not have found a community of artists. He had not achieved celebrity. But he was finding a base, a stage, on which to enact his life as an artist.

Telegraph Poles (pl. 1), typical of these early paintings, uses the nominal subject on an abstract or formal level, as strong vertical and horizontal architectural elements. This unequivocal view of composition will be a consistent theme in Wally's paintings. Buildings are, for him, intellectual units which form an architectonic structure for painting; architecture is both subject matter and the raw material of formalist plastic painting. Earth, streets, placement of a fallen sign, and leaning post, all congregate under Smith's direction to establish a tension of vertical-horizontal patterns.

There is no indication that *Telegraph Poles* (or its siblings from the thirties) was painted as a class assignment. Yet some of the obvious and lavish attention to construction, to composition, suggests a student at work.

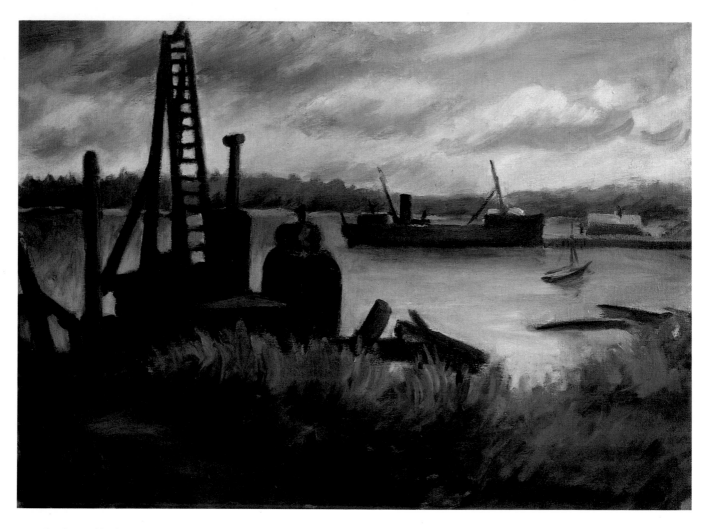

4. *Black Hulled Boat*, 1930s oil on canvas, 21″ × 29″

The bold composition of *St. Louis Street Scene* (pl. 2) is emphasized by contrasting rigid vertical-horizontal elements throughout the painting. A minor slanting theme, as seen in the telephone wires, the cross bars on the pole, and the signs attached to the building or standing free, remains throughout the painting subordinate to the dominating architectural elements of horizontal and vertical lines.

The dark foreground, lighter middleground, and light horizon along the tops of buildings, protect Wally from the intellectual and technical problems of color in this early painting. The use of tone, rather than color as it is generally understood by painters, gives the picture a solid, academic mass. But despite the Regionalist play of light against dark, the painting remains essentially a student's paean to traditionalism as defined by European painting.

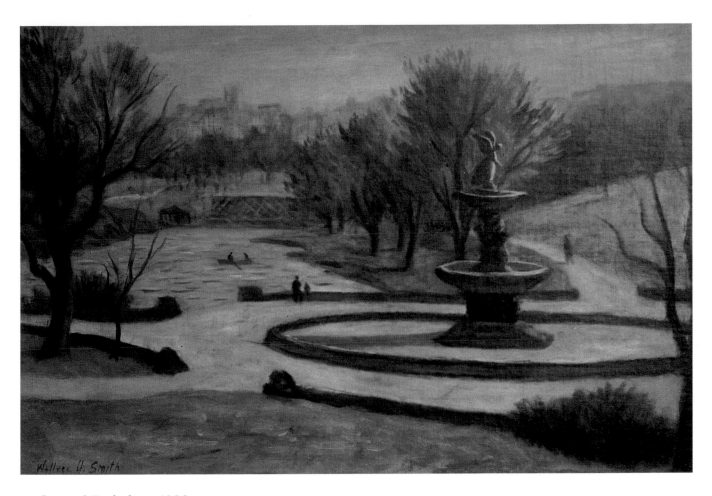

5. *Central Park*, late 1930s oil on canvas, 24″ × 36″

In his scenes of Missouri, Wally tried to shape his feelings about his roots and Regionalism. He turned, too, to other places that provided focus for his continuing studies of painting and, simultaneously, offered subject matter consonant with his emotional life. He painted the shapes and qualities of New England and of the Lake Michigan shore where, for decades, he had summered with the Smith clan.

In Michigan, stalking the bluffs and shorelines familiar since boyhood, Wally sketched and painted. With the talk and values of the New York artists in his mind, he tried to find in the gentle landscape and warm sunny days of Michigan something real: that meant, he thought, something grim and industrial. But when he painted the Lake Michigan docks and their large lumber ships loading and unloading, he examined the industrial scene for its formal design features, not for its social or political values. Moreover, he turned a half-lazy, detached eye on the subject and recreated it through a Barbizon painter's sense of the world. His eye, thoroughly fixed by French painting, did not select the darker aspects of the industrial scene before him.

Later he would return to the subject and paint the *John B. John* (pl. 3), but in the 1930s he found the prototype in *Black Hulled Boat* (pl. 4) for one of his themes of Harbor Springs. In a horizontal format, the luminous sky and the heavy black and bold forms of boat and derricks forecast the melancholy mood that would appear consistently in Wally's paintings. At the same time, the horizontal composition reflects the young painter's almost indolent enjoyment of looking on, of observing from a distance.

An artist is a choice-maker and a risk-taker, facts that have now been publicly paraded until they lumber like platitudes in our perception of the stereotypical artist. Nonetheless, there remains a hard core of truth hanging on these wellworn pegs. When Wally chose painting as his career or, more precisely, when he, in his intellectual, social, and psychic life, believed that he had, by talent or other manifestation of destiny, been chosen by painting to spend his life as an artist, he was conscious of (even self-conscious about) the significance of that choice. His affluent and cultured family had, in his judgment, little concern for the arts despite their support of education and other programs, projects, and institutions valuable to society.

Nonetheless, Wally's collegiate career onstage had been acceptable in the Smith milieu. So, too, was his chosen life in painting. If he knew that his appearance on stage attracted one kind of attention, he knew that his life behind the easel, though private and removed from daily scrutiny, would provoke curiosity. But Wally needed celebrity, applause, and approval, as well as solitude. Whichever way his mood swung he met anxiety and discomfort.

Celebrity is one mirror hung up to an individual; seeing himself as he is publicly acclaimed he knows that he *is*, knows that his life is not unremarked. Applause verifies existence, even when the recognition is rooted in disapproval, funmaking, or antagonism. The celebrant, however temporarily, however provisionally, can step free of the anxiety that haunts solitude. The sound of applause held Wally's depression at a psychological distance. Yet, a painter cannot easily play to an audience or hear its approval. Painting isolates painters in solitary craft.

Depression shadowed Wally's failure to find a community of artists and to find recognition for his work. He needed affirmation from other people. His sturdy veneer of jollity and clowning, constructed in childhood and refined on the Triangle Club's stage, provided the social coin by which he bartered for attention. But his jokes, even more than his public posture as bon vivant, masked threatening depression.

Held from despair by his own reliance on humor and on Kelse's affection, Wally still had not found the teacher who could chisel from his basic talent the shape of an artist. When he met Alexander Brook, he met the man who could serve as midwife to his talent and his self-confidence even if he did not conform to the ultimate teacher-friend he sought. Brook himself was often depressed and a heavy

drinker. Like Wally, he searched for a mode of painting that would include and thereby annul his darker side in the perfect order and tranquility of painting.

Lloyd Goodrich wrote:

Alexander Brook's paintings [are marked by] sensuous vitality and subtlety. His subjects are everyday and seemingly casual, but never banal; they possess visual wit, a quality never as broad as humor or as mordant as satire, but pungent. His love of painting, rooted in the senses, is revealed in the nervous life of his brushwork, the rich substance of his pigment, and the depth and resonance of his color, with its fine use of grays and blacks.[3]

3. Lloyd Goodrich and John I. H. Baur, *American Arts of Our Century* (New York: Praeger, 1961).

Brook kept a studio in the Fourteenth Street building that also provided studios for Hopper, Kunyoshi, Soyer, and Nakian. To be near Brook, Wally rented a studio there. Under his teacher's influence, Wally introduced higher-keyed colors into his paintings as he frankly retained from his studies of Regionalism a simplifying manner of drawing objects. From French Barbizon painting, he appropriated a rich, active brush. Brook encouraged him to incorporate his interest in and knowledge of architecture, to learn from Hopper the uses of the sunwashed architectural plane, and to use and re-use still lifes as the basic and on-going means for studying form in painting.

Moreover, Brook encouraged Wally to treat cityscapes as still life composition. In the paintings of New York City from this period, Wally engaged the drawing skills that he learned as an architect in the contest with paint to give form to image: he drew with paint and let the brush-drawn shapes stand, without extensive editing, as the image itself. Brook provided the reassurance Wally needed to handle paint more directly, to be simpler and more immediate in painting.

In *Central Park* (pl. 5), with the dominating fountain, the spring freshness of the park, and the pale cropping of distant buildings, Wally rehearses some of his major themes: architecture, nature, and water. The figures, merely sketched in oil paint, occupy space as attitudes rather than as descriptions of particular people and the distance between them. This treatment of figures suggests the artist's own loneliness in the city, his sense of people operating in isolation, and his kinship to Hopper.

Union Square (pl. 6), as seen from the window of Alexander Brook's Fourteenth Street studio, may have been a subject assigned by Brook or suggested by Hopper. Literally removed from and above the scene before him, Wally painted a bustling and vigorous part of New York City. But he invested the scene with a sunny calm that would have been unusual in the actual life of the Union Square in the Depression era. The painting, with its feeling of frozen or suspended action, almost certainly projected Wally's own wistfulness, his recollection of other times, his extraction of attitudes and feelings about sunshine and space and buildings as applied to Union Square.

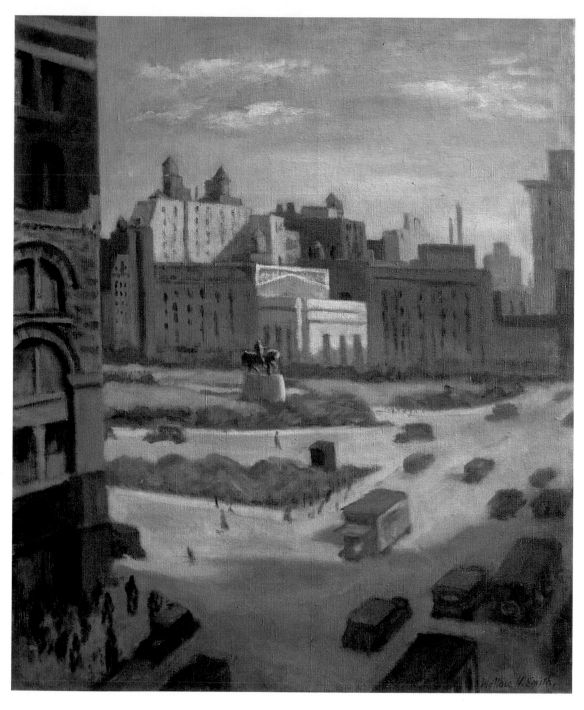

6. *Union Square,* 1930s oil on canvas, 30″ × 25″

7. *Road to the Sea*, 1930s private collection, oil on canvas, 21″ × 29″

In the Fourteenth Street building, Wally and the other artists worked and talked. They found time, almost daily, to fuss together about their plight as artists, to have a few drinks, and to exchange intelligence on dealers and exhibitions.

Brook and Wally both found the practice of art psychologically perilous. But the friendship of another artist, however uncertain that artist might be as to his own position in the art world, encouraged Wally. He and Kelse, moreover, loved Peggy Bacon, Alexander Brook's wife and a well-established artist herself. The two couples became fast friends, sharing social as well as artistic interests.

Alex and Peggy, like Wally and Kelse, had spent time in Paris and, like the Smiths, they revered French painting while earnestly exploring the paths then assigned to American painting. Peggy, like Kelse, cherished her roots in Connecticut and preserved a New England propriety in her economy of action and words.

In her book, *Off with Their Heads*, Peggy described her painter husband:

Small, hard, continentally backless head, coated with a short thatch of light brown hair like a piece of beaver fur. Big hooked nose like a weapon. Fierce blue eyes beneath a cliff of a brow, with the black look of an animal glowering from its lair, a violent stare compounded of a rage and gaiety, slightly berserk. Bull neck, broad shoulders and an air of force and energy. Mercurial, over-bearing and intense. A stiff proposition.[4]

4. Peggy Bacon, *Off with Their Heads* (New York: Robert McBride and Co., 1934).

If Alexander Brook afforded easy companionship and encouragement to Wally, Peggy, with her keen intelligence and quick wit, her agility with language, provided the theoretical and philosophical tutelage that would finally undergird Wally's work and his psyche. "In an artist's conception of life, naturally," Peggy said, "there is nothing more important than being an artist. Certainly I never felt there was anything as important." Peggy had no time for doubts or uncertainties.

Early in the 1930s, encouraged by Peggy and Alex, Wally and Kelse rented John Dos Passos' house in Provincetown, Massachusetts. This time, Wally would be prepared for Provincetown. He would make great public strides as a painter, he told himself.

Wally thought about painting and, especially, about American painting. If American painting is characterized often by an austerity and economy like that of Hopper, surely French painting occupies the opposite pole. The full and active-brush painting of the French produces a style of painting in which the lusciousness of paint is explored without inhibition and where, without apology or hesitation, the artist pursues beauty. Wally wanted to find a synthesis, wanted to effect an economy of image that, at the same time, would comfortably support his sensuous pleasure in brushwork and his sense of beauty as defined by the work of the French masters. He would find the synthesis during the summer in Provincetown. He would learn to paint an American vision with a French brush.

In Provincetown, he turned to another teacher, Charles H. Hawthorne, who, like the earlier Farnsworth, reduced art to formula and teaching to harangue.

Peggy Bacon had studied with Hawthorne. Even as a young woman, Peggy's artistic gift would not be bounded by directions from any teacher. Moreover, her acidic sense of humor and irreverence would not stay on lead in the presence of such a teacher.

For Peggy Bacon, Hawthorne was a pitiful, ridiculous teacher. At the time that she studied with him, she had gained confidence as an artist and, unlike Wally, was immediately and completely impatient with Hawthorne. Some fifty years later, recalling Hawthorne's classes, Peggy's responses to him were undimmed:

He had a huge class of women except for one man, Bunny Brooks from Boston. Hawthorne is very pompous, much above his students, and he'd stroll in white flannels among the class saying "That's good." "That's not good." We weren't allowed to include features in portraits. Everything was a tone on a tone. Oh, it was a silly method of teaching! Every Saturday morning he would have a display of our work in a studio barn

Kelse and Peggy Bacon, late 1930s

and two servators would place the pictures on tilted racks, a pair at a time, and Hawthorne would comment "That works well." He would say "Not so well." He went on all morning. Since it was excessively hot and stuffy several women would faint during this ordeal and they would be revived while Hawthorne spoke. He was a man of ideas.[5]

5. Quoted in *Maine Sunday Telegram*, June 17, 1979.

In New England, Wally soon broke free of teachers and, on his own, painted a series of watercolors and oils. His *Road to the Sea* (pl. 7), while redolent of lessons learned in Regionalist painting, evokes the windswept sea edges of New England where greenery remains low and pruned by salt winds, where skies hang close to the earth on dour days. The subject embodied feelings of melancholy, always present to some degree in Wally's personality, that threatened to hang like the New England sky over his days in Provincetown. But there were bright blue days, too, when Wally's wit sparkled and his spirits soared. He rejoiced in having overcome a need—real or imagined—for a teacher.

Back in New York, Wally and Kelse saw Peggy Bacon regularly, sometimes with Alex and sometimes alone. Peggy prodded and encouraged Wally, enjoyed his humor and wit, appreciated Kelse's grasp of art and abiding dedication to Wally and to young Jay Smith.

In 1933, Wally's work was included in a group show at the Museum of Modern Art in New York, an honor which invigorated the artist and which, by his reckoning, promised a large audience. But the show ended; the promise of the sweet sound of public applause died with it. Wally continued to work, continued to turn to Brook and to Peggy for advice and guidance.

In 1937 Wally had a one-man show at the Reinhardt Gallery in New York. And, in 1938 a painting from that show, *Hell-Gate Bridge,* was reproduced in the Living American Art series. A later painting (pl.8) of the same subject resembles in mood the original picture. According to Peggy Bacon, "This peaceful river scene with the sun softened by the slight haze from the water suits the artist's temperament, and the colors emphasize his pleasure. A soft light blue dominates, being represented in sky and water. The brick red buildings, and light ocher masonry of the bridge, and the yellow chimney of the tugboat serve to enhance the quiet happiness the scene evokes in the artist."

Even with these successes, Wally longed for a wider recognition and for more public understanding of his work. Peggy wrote at the time:

Wallace Herndon Smith is so lighthearted and unassuming that he never seems to be taking himself or his work altogether seriously. In manner indolent, his clear, somewhat remote blue eyes wander speculatively over an active world in the apparent detachment of a noncombatant. His face wears the expression of a village loafer sitting on the steps of the general store watching the folk go by and, possibly, whittling. Rangy, easy-going, casual, witty, he has a quality as native to America as Huckleberry Finn. . . .

Some there are, perhaps, who, taken in by his carefree dismissal of himself from conversation, may be inclined to make light of the man and his work. An insistent ego has so long been considered the inevitable birthright of a creative nature, that a man so

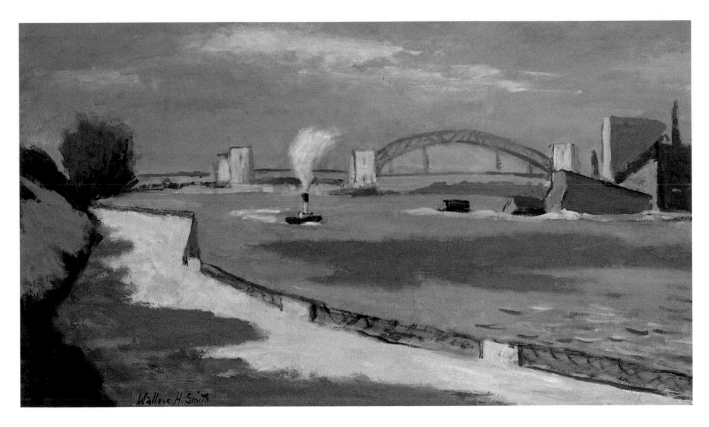

8. *Hell-Gate Bridge,* 1960s private collection, oil on artist board, 19″ × 33″

obviously without it, scarcely impresses even his fellow-artists as one to be reckoned with. The public at large is slow to note progress that is entirely untrumpeted; most dealers are leery of taking on late-comers; the critics seldom notice what is under their noses until it has been there a long, long time. . . . But while a too modest sense of his own proportional importance in the scheme of things may handicap him from a practical point of view, the merit of the work itself must eventually come to the rescue; for Smith has all the attributes which are of real importance to the making of good pictures. He is gifted with fine talent and appreciation. He is also observant, adaptable and very clever; and no artist is more deeply earnest, more hardworking, thoughtful, persistent, and singleminded. He is in his studio for many hours, nearly every day in the year, and steeps himself in all the interests allied to his profession, frequenting the galleries and museums, reading much on art and studying the techniques of painting. . . .

His pictures themselves are like him in their lack of show or flourish. They are sensitive and economical, subtly subdued in color, restrained in their rejection of the stylized, and make no attempt at the dashing effect. The landscapes in particular appear to retreat and wait for an attentive observer to come along and notice their quiet virtue. But though they are generally very mild in mood, the canvases have structure and atmosphere and a very persuasive tonal quality; and once observed they shine like open windows. Sincerely and searchingly handled, harmonious in color and contour, their appeal lies also in their reserve. They are delightful paintings to live with for they grow on you.[6]

6. Peggy Bacon quoted in "Peggy Bacon's World," *Boston Globe Magazine,* July 8, 1979.

In 1938-39, Wally and Peggy taught at the Tyler School of Art in Philadelphia. When illness forced Franklin Watkins, a distinguished faculty member, to take a leave of absence, Brook suggested that his pupil and his wife replace the well-known artist-teacher.

Watkins (born in 1894), slightly older than Wally, enjoyed the esteem of the art world and the visible spoils of success. He won the Carnegie prize for his painting *Suicide in Costume* and, despite a lustrous career as a teacher, was lauded as a solid and productive artist. Wally admired him for the academic solidity of his work and for his success. Being selected to substitute teach for the prominent artist reassured Wally and seemed to promise the recognition that he sought.

The teaching venture assumed an even happier dimension for Wally because he could share it with Peggy. He loved Peggy's wit and incisive intelligence, appreciated her personal chic, depended on her honest-to-the-bone comments about his work.

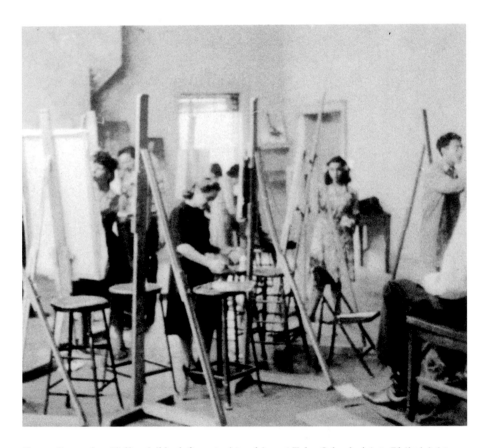

Peggy Bacon (partially visible, left center) teaching at Tyler School of Art, Philadelphia, 1938

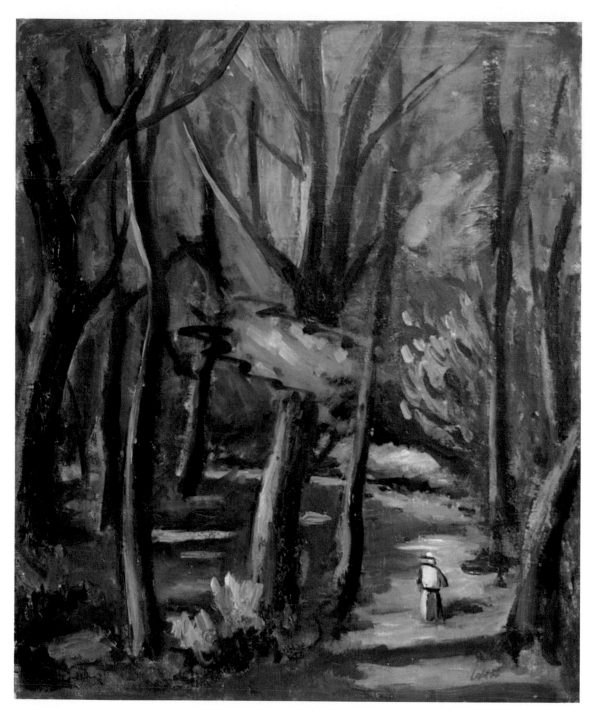

9. *More Woods*, 1940 oil on canvas, 29″ × 24″

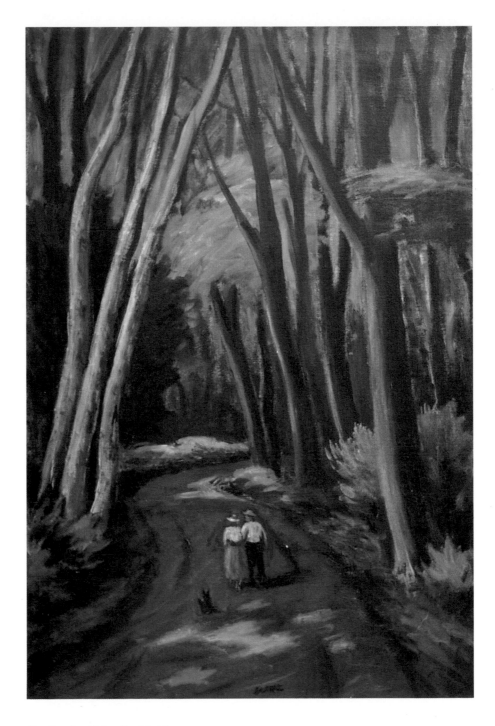

10. *In the Woods,* 1940 oil on canvas, 36″ × 27″

She, more than Brook, had become his real teacher. During the academic year, the two friends traveled together each Monday at seven in the morning from New York to Philadelphia, talking and laughing together. At the Tyler School, Wally taught painting with all the confidence and authority he could invest in the task. Peggy, in her wry and warmly amused fashion, put her students through paces in drawing and printmaking.

The friendship with Peggy deepened. Soon Peggy, Kelse, and Wally shared dinners and weekend sketching trips. In the summer of 1940, now separated from Alexander Brook, Peggy joined Wally, Kelse, and young Jay in Michigan where Peggy and Wally painted and sketched together each day.

Peggy, a nearly constant companion to the Smith family, was to Jay "a perfect miniature." A tiny person with small precise features, she wore little hats with clusters of cherries on the top. Jay found Peggy's presence magical. As she dished up a witty remark, perfectly phrased and cadenced, she would laugh until the cherries on her hat shook, a delicious emphasis, Jay thought, to the merriment that seemed to surround her.

Peggy's claim on art, nurtured from childhood by her artist parents, was absolute. She suffered none of the doubts that plagued Wally. She enjoyed success as a caricaturist and as a printmaker but, regardless of public enjoyment of her work, she concentrated on her satirical drawings, her portraits, and the drypoints and etchings that, through publication in *The New Yorker, Vanity Fair,* and other periodicals of the day, increased her audience and her stature as an artist.

Peggy's confidence and success, shared simply and frankly with Wally and Kelse, seemed to shelter and sustain Wally. Being close to Peggy was, for him, a way of being close to the center of the art world; Peggy, after all, was an artist, the real thing.

When Peggy returned to New York, however, clouds of depression descended again on Wally. He began to brood about his own merit as an artist and about the seeming inaccessibility of public awareness and success as a painter.

His studio in Harbor Springs, built into the servants' quarters above the garage, furnished him sanctuary. There, amidst the flotsam and jetsam of a painter's life, he thought about painting and about how he had come to be a painter and about what it meant to continue to be a painter.

As he sought to understand himself as a painter, he painted the woods near the studio, the calm, dark, earthy smelling damp woods edging northern Lake Michigan. In the shadows and sun streams of the Michigan woods, with trees arching into great cathedral naves, he set small anonymous figures. A single figure, for instance, in *More Woods* (pl. 9), walks away from the viewer into the dark and solemn hush of the woods. Above the figure, Wally's brush actively describes the edges of foliage, the shapes of trees. *In the Woods* (pl. 10), another painting from the same period, contains a couple who could be Wally and Kelse accompanied by their small Scottish terrier, Pee Wee; it is a painting that reflects again the imagery and style associated with Regionalism but with a darker, more brooding quality than that typically associated with the Regionalists. The figures,

Peggy Bacon drawing in woods near Harbor Springs, mid 1950s

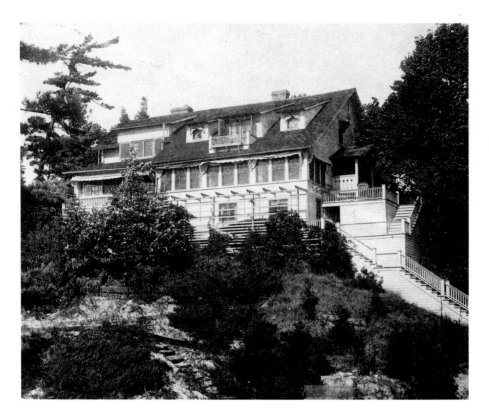

The summer cottage at Harbor Springs, 1940s

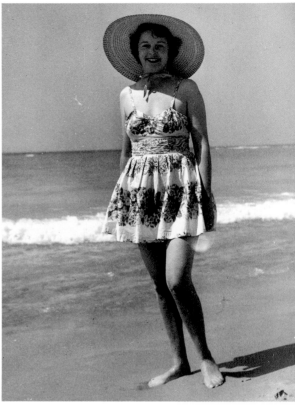

*Kelse in Fort Lauderdale,
Florida, 1940s*

close together, even touching in uncharacteristic fashion for Wally's figures, nonetheless seem in danger of disappearing, of being consumed in the enormous trees and the dense foliage; seemingly without destination, these figures move through the muted shadows, actors on a melancholy stage.

In a similar setting, Wally placed a young boy (pl. 11) who resembled his son. Jay was a rangy, quiet boy whose graceful gravity and intelligent humor charmed his parents as well as their artist friends in New York. The boy in the painting wears a striped shirt similar to those worn by Jay as he enjoyed summer in Michigan, and the boy carries Wally's painter's hat, an old straw hat that occupied a place of honor in the shadows of Wally's studio. The painting was never identified officially by Wally as a portrait of Jay but both the pose and the physiognomy argue that indeed it is a depiction of Jay, painted half from the boy attentively but casually posing and half from Wally's recollection of his son as he worked alone in his studio.

He also painted a brighter, higher-keyed painting of Kelse (pl. 12) in a fashionable bathing costume of the period, similar to the one worn in a visit to Ft. Lauderdale. Both the picture of Jay and that of Kelse testify to Wally's ability as a portraitist. He had a sense of his subjects' characteristic bodily movements and stances, a notion of the role of physical characteristics and manners in establishing and revealing character.

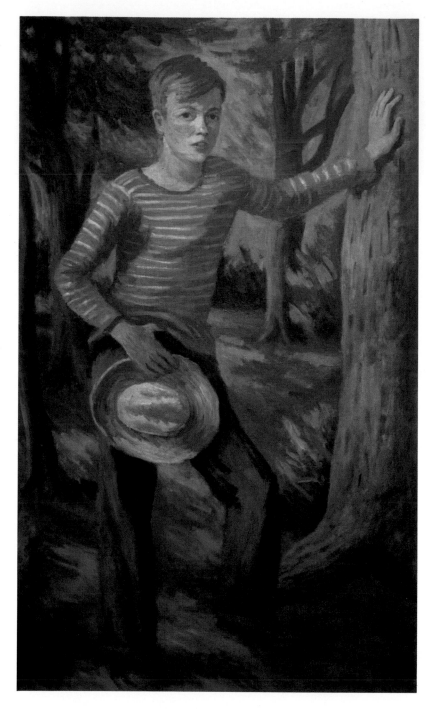

11. *Boy with Straw Hat*, 1940 oil on canvas, 48″ × 28″

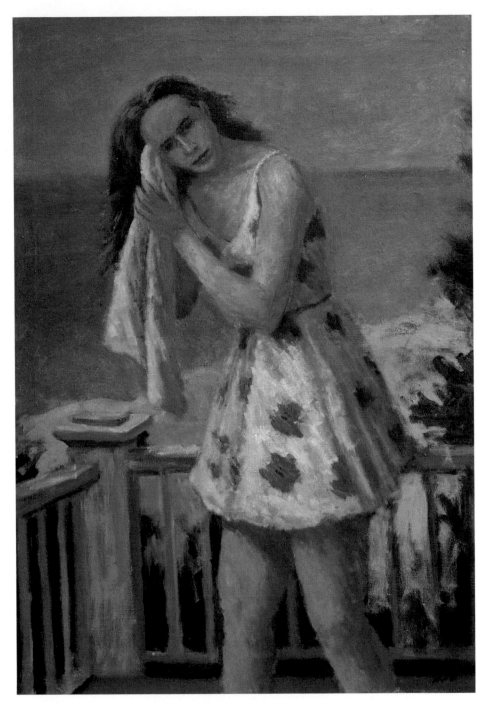

12. *Kelse Drying Her Hair,* 1940 oil on canvas, 40″ × 28″

In the 1930s in New York, Wally had studied briefly with Nicholaides ("hard work but good") and since that time had worked to catch in quick deft thirty-second sketches the essential identity of a person through his or her pose.

During the summer of 1940, Wally mentally sifted through his experiences in New York, took stock of himself as a painter, and quietly came to grips with the important factors in his life. Painting, yes, important. But painting could not be allowed to expunge his family or to remove him from the serene places associated with childhood and roots. He was, he realized, not willing to compete in the New York art world if it meant endangering his family, threatening his summers in Michigan, or placing in peril the people and moments that mattered to him. This, he realized, could become sentimentality in conversation. He chose not to discuss it, not to maunder about people and places too close to his heart for words to describe. Here, he had to acknowledge, was a source of energy—was inspiration too great a word?—a source of steadiness and direction for him. He vowed not to risk it for art.

Did this, Wally wondered, remove him from art forever? Would he be ravaged by his own decision, made victim of his own heart?

Walt Kuhn's earlier challenge, kept alive in conversations with Kelse and in jokes with Peggy Bacon and Alexander Brook, still smarted. Wally was sickened at the idea of being "an applecheeked countryclub boy" and, equally, at the prospects of drearily competing for a place in the art world, repeatedly having hopes dashed as shows opened and closed without adequate public notice. He felt that his talent was unfocused, that his energies were undirected and he knew that both talent and energy would turn against him, could begin to corrode his spirits and his zest for life.

He had attracted some attention from artists he respected. He had begun to exhibit even if the exhibitions did not attract wide acclaim. He had, according to his own standards, earned credentials as an artist. Yet, the artist's role as defined by the frenetic promotional activities of Kuhn ("He was always sucking up to someone," sniffed Peggy Bacon) or by Alexander Brook's drunken and often suicidal periods, or by Hopper's belittling of his wife's efforts as a painter, repelled Wally. And the range of interest, as delimited by Fourteenth Street and a gaggle of galleries and approved political causes, seemed to Wally as provincial as the shallowest eddies of St. Louis social life.

He was, he admitted to himself, without community, save for his family. For them he would continue to shine as entertainer. And he had ghost-friends, artists who lived vividly in his imagination and in his reverence for their work; they defined "artist" for him and expanded, rather than limited, interests for him. The adolescent dream of being an artist in the company of other artists, of extending forever the camaraderie of the Triangle Club, faded. Amen.

*Kelse and Wally on the deck
of their summer cottage
at Harbor Springs, c. 1940*

The War Years

Connecticut, 1940–1942

In the autumn of 1940, Kelse and Wally gave up their apartment at 168 East 74th Street in Manhattan and moved into a spacious rented house on Greely Road in New Canaan, Connecticut, not far from Higganum, Kelse's forebears' home. There was open country, the smell of the Long Island Sound mingling with the fragrance of fields and wooded areas. The house itself, set well within a large expanse of coastal Connecticut land, amused the Smith family. They found it picturesque but, at the same time, comfortable and unashamedly beautiful. They were protected in this rural haven. Wally commuted each day from New Canaan to New York, following the schedule of the businessmen from his suburban community. He kept his studio on Fourteenth Street in proximity to the studios of Hopper, Kunyoshi, Brook, Soyer, Marsh, and Nakian.

The move to Connecticut, geographically as well as spiritually and intellectually, divided Wally's life into two seemingly incompatible portions, a division even sharper than that between uptown and downtown Manhattan. On the one hand, he now lived in an affluent Connecticut community, a country squire among other country squires. On the other hand, when he and the other men from New Canaan commuted into Manhattan, the businessmen, buttoned into their three-piece business suits, carrying briefcases, reading *The Wall Street Journal*, went into the world to meet the schedules and demands of offices on Wall Street or in other parts of New York's financial, legal, and commercial communities. Wally, dressed in the crumpled casual tweeds and flannels of the countryman, made the trek to New York and, instead of the rigidity of the office, confronted the extraordinary and anxiety-inducing freedom of his studio.

In that studio, he could do exactly what he wanted, or nothing at all. He could chain himself to routine; could set up goals as he set up still lifes; he could finish paintings; he could study and sketch. Or, he could stare out the window. He could drink. He could gossip with other artists. No one gave a damn.

In Connecticut, Wally and Kelse entertained friends regularly, among them their neighbors, Cassie and John Mason Brown. Wally, removed from the dizzying freedom of his studio and from the Bohemian side of his life on Fourteenth Street, reverted to his theatrical Princeton ways of joking, telling stories, and singing to his own piano accompaniment. He occupied center stage in his New Canaan neighborhood and became the grown-up character, "Wally," that he had created in an earlier and younger form at Princeton.

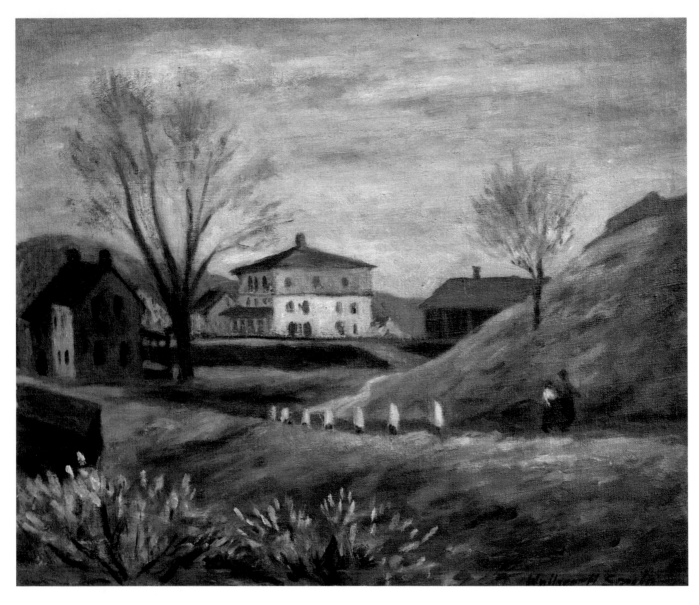

13. *New Jersey Landscape*, 1930s private collection, oil on canvas, 16" × 19"

On weekends, Peggy Bacon often visited the Smiths in New Canaan and, there, at ease in the bucolic country so like her native Ridgefield, Connecticut, she enjoyed the warmth and cheer of the Smith family. A deep and easy friendship had grown between Wally, Kelse, Jay, and Peggy; their shared lives and complementary interests in art provided continual instances for expression of affection.

On a Sunday outing to New Jersey, typical of the weekend trips the Smiths enjoyed together, Wally and Kelse visited family in Montclair. Then, with Jay,

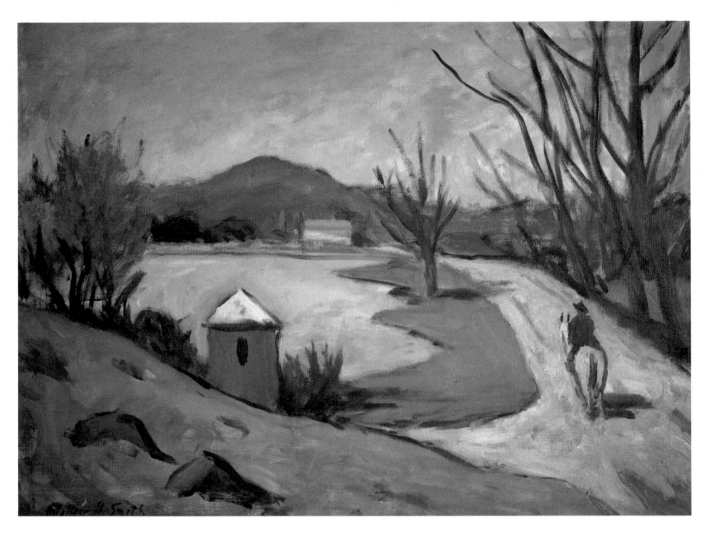

14. *Riding in Connecticut*, 1945 oil on canvas, 25″ × 33″

they drove to the western reaches of the state beyond the sophisticated precincts of Kelse's girlhood. There, on an early spring day, Wally painted a small, carefully modulated rural scene: *New Jersey Landscape* (pl. 13). In this picture, as in many of Smith's works, figures wander purposelessly, evoking neither a sense of their identity nor their destination: they function as weights of color or texture; they anchor a portion of the total composition. They are actors in the drama of composition but, nonetheless, their presence sets the scale of the paintings. More importantly, the figures, by the fact that they are subsumed in the total fabric of nature as reinvented by the artist, add poignancy, emphasize the overall sense of loneliness that stains the painting. They are more cherished figures because they are without identity; more important in the symbolism of the painting precisely because they exist without inferable purpose or activity.

While Wally lived in Connecticut, he combined in his painting the unlikely forces of suburbia and Bohemia and, in the process, struck from his anvil some hard and sharp paintings, boldly painted and strongly composed. One such painting, *Riding in Connecticut* (pl. 14), usurps the Connecticut landscape to serve the spiritual forces that then impelled Wally in painting, forces glimpsed in earlier works but now maturing and insisting on the painter's reckoning. In the Connecticut landscape, true to his understanding of the architectural base of painting, he revealed pyramidal and triangular forms, almost building-like in mass and presence, to define rocks, mountains, lake or reservoir edges, and the tops of the little buildings that occupy space in the painting. A solitary figure on horseback rides away from the viewer. The figure, seen from the rear, cannot be identified; but is it an accident that the man wears Wally's hat, that he shows the set and bend of Wally's shoulders?

As in earlier paintings, this solitary figure is placed in nature. The road has no destination. The implied journey has no beginning and no end. The figure does nothing save, in this instance, sit astride the white horse.

So far as Wally's records reveal, this was the last painting he finished in Connecticut.

On Sunday, December 7, 1941, the Smiths were entertaining friends at lunch in their comfortable home in the country. A neighbor who had not been included in the party rushed in shouting, "Turn on the radio, turn on the radio." Conversation stopped and while the guests tried to make sense of the neighbor's urgent cries, he added, "They're bombing us." The Smiths and their guests, knowing the interloper's proclivities for alcohol, assumed that he was well under its influence. When the message-bearer dived under the piano, still wailing, they were prepared to dismiss his cries as an inept joke among joking neighbors. Soon, however, they were persuaded to tune in the radio and, with millions of other Americans, they learned of Pearl Harbor.

Talk of war—of Hitler and Europe, of England and of the United States' loyalties—hummed in Connecticut as elsewhere. But even so, the news of the Japanese attack staggered the revellers. The next morning Wally telephoned a friend from Princeton who lived in Washington and who, to Wally's vague recollection, worked for the government. Through this friend, Wally managed to make an appointment with yet another friend who, he believed, "was handing out commissions." He flew to Washington and returned to Connecticut as a captain in the Camouflage Corps. "I was given a costume," he said, "but I never wore it."

Wartime soon hung over Connecticut, creating an atmosphere of drabness and austerity that bored both Wally and Kelse. Gas was scarce and car rides curtailed. Commuting was tiresome. Friends' lives were being disrupted by the war, by jobs and by family members entering the armed services.

There was a great deal of speculation about safety on the Eastern seaboard at that time. Was the coast of Connecticut safe from invasion, from air attack, from enemy submarines landing? No one knew and everyone speculated.

As the neighbors gathered in New Canaan and as the drinks were passed round, the adult children of suburbia, exercising the darker arts of one-upmanship, set about scaring themselves and each other mercilessly. After a while, they believed the horror stories that they concocted. They believed that the East Coast of the United States was in danger of invasion; they anticipated being bombed; they heard sounds and saw sights that they could not identify.

St. Louis, 1942

In the spring of 1942, Wally decided to move his family to St. Louis. During the Christmas period of 1941, Wally had returned to St. Louis to visit his mother. She wanted her son and his family closer to the rest of the family. And, after the struggle with the art world in New York, after the difficult and tiring commute from New Canaan to New York, and with the clinging sense that he was not gaining recognition or reward as a painter, St. Louis seemed more attractive to Wally than it ever had in the past. Now, too, the country was entering a war: how long would it last? How threatening would it be to Wally's family?

Despite protestation from both Kelse and Jay, Wally determined that the family would return to St. Louis. He would thereby escape whatever imagined threats the war posed as well as those quite real perils that he encountered on Fourteenth Street where, finally, the enemy was himself—his fear, his doubts, his continual bickering with his own talent. These were not the reasons announced, however, by the father who ostensibly sought safety for his son or by the husband who wanted security for his wife. Neither son nor wife wanted to pay the price of living in St. Louis for the promised safety and security. But Wally overrode their objections and tears.

The Smiths moved to St. Louis and settled into a newly built house, chosen by Wally, at 51 Pointer Lane, a house that Jay openly considered ugly in a neighborhood that he found hostile. Kelse, too, found the house stark and raw after their mellow country house in Connecticut's lush landscape.

Their furniture, during wartime years, was slow to be shipped from New Canaan to St. Louis. The bare interior of the house, the bleak exterior, and the unrelenting reality of being in St. Louis weighed heavily on Kelse. Jay, too, found himself under a cloud of oppressive sadness.

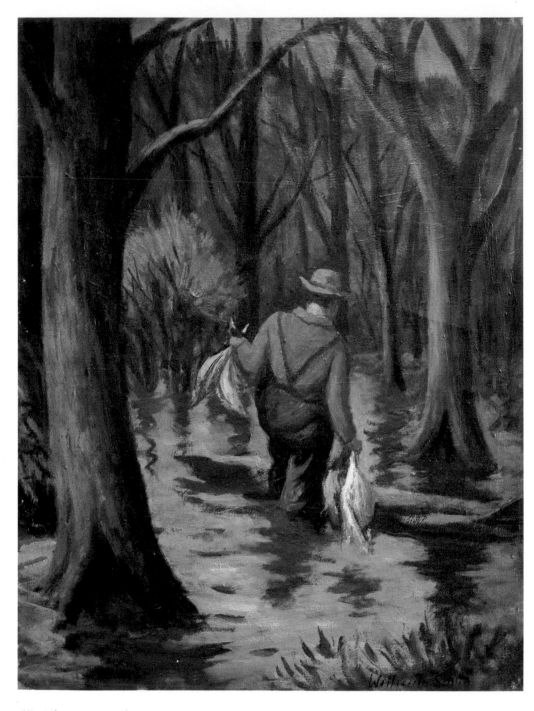

15. *The Hunter,* late 1940s oil on canvas, 36″ × 27″

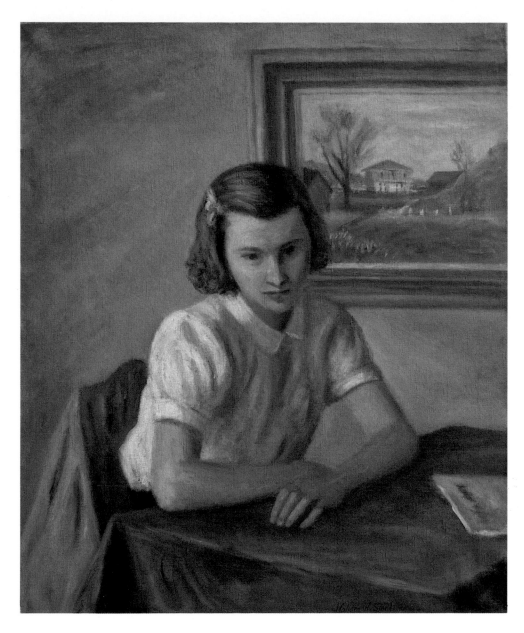

16. *Girl with New Jersey Landscape,* early 1940s oil on canvas, 30″ × 25″

In the fall of 1942, the furniture arrived. The Smiths planted trees, including the oak tree which, forty years later, shades a large section of the front yard. Wally built a loggia around the back of the house and spaded a victory garden into the rich Missouri earth. Each member of the Smith family made peace with the new surroundings. Here, thought Kelse and Jay, they would wait out the war. Here, thought Wally, he could be himself; he could paint in the protection of a familiar world.

The Camouflage Corps, to which Wally had been assigned as a commissioned officer, was by this time stationed in Missouri. Captain Smith was not called up to serve, but he chose nonetheless to mingle from time to time with his fellow officers. "The Camouflage Corps," according to Kelse, "was a joke. They fought the war in the bars of the Chase and Park Plaza hotels."

The members of the corps may not have distinguished themselves as valiant warriors but many of them were highly creative men: stage designers Donald Oenslager and Jo MelzT and Bostonian Nat Saltonstall among them. With them Wally recreated a pale version of his life in New York.

Kelse and Jay, however, found no reasonable means for reconstructing their lives. Back in St. Louis, in the shadow of family ritual and expectations, Wally, now in his forties, painted steadily but under a cloud of melancholia. He had left New York, the presumed center of American art. He had abdicated the small place that he had obtained for himself in the art world. He was, he knew, risking professional and intellectual suicide by removing himself so completely from that art world. He lived in the shadow described by a fellow St. Louisan, T. S. Eliot, who had earlier escaped to the mythic safety of expatriation:

Wally sailing at Harbor Springs, summer of 1945

> Between the idea
> And the reality
> Between the motion
> And the act
> Falls the shadow

After his return to St. Louis, in an effort to help the country's defense industry, Wally worked at J. S. McDonnell's factory and established for himself a routine of painting in off-hours. He painted *The Hunter* (pl. 15), which shows a family friend, Joseph Pulitzer, Sr., wading through swampy waters with prize in hand. The Missouri trees, swaying to the rhythms of Regionalism, surround Pulitzer.

17. *Model with Red Skirt,* 1940s oil on canvas, 40″ × 24″

But Wally's interest in the figure, awakened especially by his earlier portraits of Kelse and Jay, could not be limited to the friends and family figures he might persuade to sit or stand for him. He turned to models and painted a serious, slightly brooding young woman at a table, her arms folded, her hair barretted back in the fashion of the 1940s (pl. 16). Behind her is Wally's little painting, *New Jersey Landscape.* Taken together, the portrait of the young girl and the small, mellow landscape painting reveal the mindset of the painter. It is a reach for painterliness, for controlled organization with a soft rich surface. And it is, finally, a painting that blends the American austerity with the French brushwork which Wally admires. A modest painting, grand neither in scale nor in composition, neither flamboyantly painted nor highly colored, it reveals clearly a choice made. Could this painting, and the personal and professional decisions on which it rests, have been made earlier? Isn't this subdued painting a mature painter's signpost to himself, with reference to the past *(New Jersey Landscape)* as well as suggestion of the future?

In another painting from this time *(Model with Red Skirt*, pl. 17), Wally found a model who could hold a pose intended to suggest the intimacy and gentleness of a private domestic moment: a Balthus-like woman fastens her skirt; she is slightly preoccupied in manner; she shifts her body and weight to perform the simple, daily, ordinary act of fastening a cotton skirt. An old raincoat or canvas painter's smock hangs above a daybed that is casually draped in faded fabric. A stack of paintings leans against the wall behind the daybed. The setting suggests a studio, a work-living place where trivial, daily actions assume symbolic significance.

Long after Wally had studied with Farnsworth and Hawthorne in Provincetown, he returned briefly to the method that Farnsworth forced upon his students. He knifed paint onto a masonite surface; he used bright and high-key color, and he used subjects that remained in his memory as associated with Provincetown. In *Boats in Provincetown* (pl. 18), he let the knife lead him into simpliflying the plane and the strong deployment of architectural elements. The resulting painting is merry, sparkling, and solid.

In the 1940s he painted the Holy Childhood of Jesus Roman Catholic Church in Harbor Springs as seen from the bluff above the little town. The glowering sky presses down on a deeply shadowed lake surface and hangs darkly over a somber landscape. While the trees, softly painted in the French manner, embrace the more sternly painted church, the painting remains one with a mood of unmitigated sadness and brooding.

In similar paintings from this period, Wally tried to establish his mature voice, not an easy matter for a painter who has elected to leave the art capital of the country and who, without having solidified his professional reputation, planned to paint in the comfortable and familiar world of his family. How would he reconcile his professional needs with his personal life?

Model with red skirt

While the country was at war, Wally fought his own internal war as an artist. He had to find direction and tone, psychological and intellectual, for his paintings. Perhaps he was aloof, and perhaps snobbish. His dirty-handed approach to his work did not diminish his quasi above-it-all position regarding art; he wondered if he were the sole keeper of traditional forms and styles in art, if he alone reiterated serious questions about the nature of art.

Regardless of the particular position of a particular painter between the real or imagined poles of traditionalism and modernism, imagery will demand its due. And what is imagery? The object painted? The painting itself? The paint of which the painting is made? And what enlivens image? What breathes into lumpish clay the quality and energy of life? Does an artist, whatever his social and historical definition, function as a craftsman, as one who applies paint to surface with recognizable, measurable skill?

Main Street, Harbor Springs, late 1940s

18. *Boats in Provincetown*, late 1940s oil on artist board, 20″ × 24″

As a craft, painting's purposes are determined by the outside world; it becomes one form among many forms, a service provided by those who keep the rules of order, an understood system of communication. There had to be clear purposes and graspable meaning in art. Painting had to issue from intelligence and talent, had to be the product of those specially gifted and ignited by holy fires.

He lived in a period shaded by Freudian thinking about individuality and being. Did he control his destiny or was he, as he feared, a victim of the talent that he took as the basic article of faith in his being? Could he sift through his experiences and dreams, his memories and feelings, and find images agreeable to himself, images that would make life bearable? Or, stripped of the universal verities he wanted to find in art, would he be cast onto the terrible sea of total freedom? If he feared freedom in his life, considered it to be merely an uncomfortable

19. *Paris, Early Morning*, 1950s oil on canvas, 21″ × 29″

manifestation of abandonment, of not belonging to time or place or person, he
feared freedom in art as the beckoning toward chaos, loss of control, and ultimate
failure.

What should he do?

The Mature Artist, 1950s

Wally and Kelse in Bermuda, 1948

During the summer and early fall of 1950, Wally sketched and photographed in France and Italy. He returned to St. Louis with his head and heart full of European sights and sounds, patterns and shapes. Throughout long solitary days in his studio, he consulted his colored slides, arranging and rearranging them for viewing. He sketched from the slides, he dreamed of France, of Italy, and of his youth. A spark of derring-do flamed; he began to work quickly, to simplify plane, to capture the still life serenity and order of city and village streets.

Over the next several years, as a consequence of repeated visits to Europe, a series of paintings emerged that disclose the artist's emotional tones of the period as well as his intellectual or formal concerns in painting.

By 1950, Wally was a fully mature artist, committed to precepts that he had devised in imaginary conversation with the Big Boys. Still uncomfortable with the loneliness that painting required, he was an extrovertive force in the St. Louis social world. He and Kelse, attractive and popular, attended and gave parties. Wally, in this, remained more comfortable on center stage as an entertainer than in serious conversation that might intrude upon the territory of painting and damage the private world that he kept secret and sacred. He had become adroit in protecting his secret world, his sealed studio, from the trespassing of casual visitors. Friends and associates knew that he painted. Some surmised that he was serious about art despite his jolly toper public persona. But only those closest to him—Taffy, Bob, Kelse, Jay—knew that Wally, now in his mid-years and aware of his mortality, served painting as a knight errant, as an apprentice still trying to show his mettle.

During the fifties several key factors shaped Wally's painting. He and Kelse began to travel widely again, always in search of both pleasure and the subject and mood of painting. Wally learned to use expertly the new 35mm cameras and, with them, to photograph the subjects and scenes that he would transform into paintings. In this decade, Wally's work, issuing now from studios far away from the razzmatazz of New York, consistently reflected his rigorous pursuit of abstract form within natural or actual subjects.

As his work evidenced increasing control and certainty as a result of his growing vision of order underlying actuality, Wally ironically attacked artists who turned completely to abstraction and to the presumed freedoms of pure form.

By 1950, the United States had put the Second World War fully in the past. The art world of New York seethed with the energies of the abstract expressionists and the debate was on, full force, about the merits of abstraction. Wally, living comfortably in St. Louis, felt the pressures of the new wave of American art. But, now an aging knight in chivalrous service to the French masters, Wally insisted stubbornly on the merits of traditional painting. Ironically, as he pursued more deeply and in more specific instances the philosophy of naturalistic painting, he became increasingly neo-platonic in attitude and, therefore, came to his own sturdy form of abstraction as the intellectual basis for composition in painting.

Meyer Shapiro, perhaps the greatest American art historian of the period, had written in 1937, well before the recognized advent of the New York School of painting:

Before there was an art of abstract painting, it was already widely believed that the value of a picture was a matter of colors and shapes alone. Music and architecture were constantly held up to painters as examples of a pure art which did not have to imitate objects but derived its effects from elements peculiar to itself. But such ideas could not be readily accepted, since no one had yet seen a painting made up of colors and shapes, representing nothing.[1]

Representation is the key word. Wally could not consider the possibility of a painting representing nothing. While he constructed paintings that indeed did represent a scene or an event, he stressed the underlying abstract factors, the elements of composition, so as to present, as if on first sight, visual data transformed in order to abide comfortably with the overall form, or composition, of the painting. Meyer Shapiro again:

In the course of the last fifty years the painters have freed themselves from the necessity of representation, discovered wholly new fields of form-construction and expression (including new possibilities of imaginative representation) which entailed a new attitude toward art itself. The artist came to believe that what was essential in art—given the diversity of themes and motifs—were two universal requirements:

That every work of art has an individual order of coherence, a quality of unity and necessity regardless of the kind of forms used; and second, that forms and colors chosen have a decided expressive physiognomy, that they speak to us as a feeling-charged whole, through the intrinsic power of colors and lines, rather than through the imaging of facile expression, gestures and bodily movement, although these are not necessarily excluded—for they are also forms.[2]

Wally understood the traditional rudiments of oil painting. He knew, for instance, that fat paint always followed lean paint, that pigments thinned with turpentine were covered by pigments thinned with oil or a mixture of oil and turpentine. He knew that warmer tones were to be laid in over cooler tones, that areas were to be worked from dark to light. He knew that a good artist knew how to draw on a gessoed surface, to broadbrush onto that surface the basic tones with lean, quick-drying pigments, and to work up the colors and tones from that base.

1. Meyer Shapiro, "Nature of Abstract Art," in *Modern Art—19th and 20th Centuries* (New York: George Braziller, 1978).

2. 1957: "Recent Abstract Painting," in *ibid.*

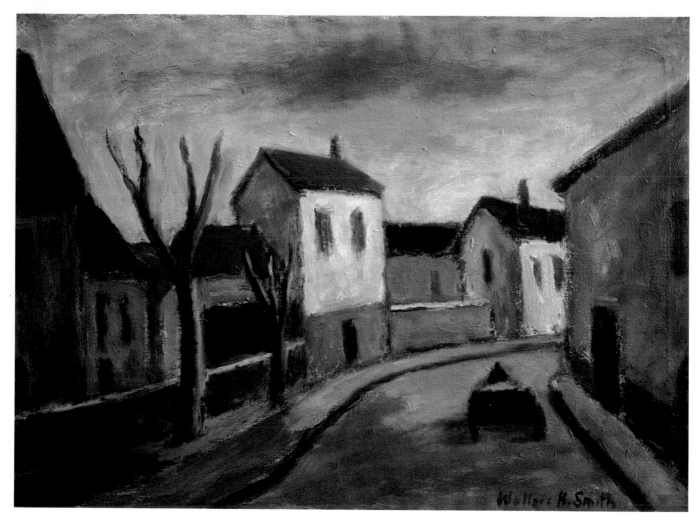

20. *Cart on French Street*, late 1950s oil on canvas, 21″ × 29″

These rules, even when he rudely affronted them, were the articles of his faith. While he vigorously rejected the serendipity and flirtation with formlessness that he thought inherent in abstract expressionism, he adopted some of the same major techniques and modes that infused abstract expressionism. He painted lean paint over fat paint and, with rag or brush, wiped at the surface to mix the two layers in some instances or, in others, to obliterate and blur images. He scratched through the surfaces of his paint to expose the white line of the canvas. His initial forays into the realm of experimentation with technique and materials were, by abstract expressionist standards, timid and contrived. For him, however, they were astonishing and freeing.

During the fifties, when he read of abstract expressionism in the journals from New York, he railed against the excesses of the new art, invoked the wrath of

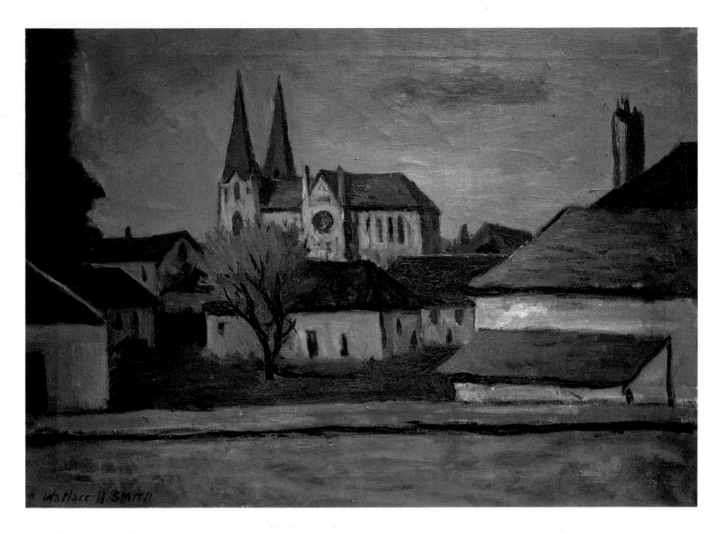

21. *Chartres*, 1950s oil on canvas, 21″ × 29″

tradition on its practitioners, and made it clear that he himself would not engage
in what he perceived to be mindless and irresponsible caprice in paint.

Wally was invited to address The Round Table, an organization of businessmen
who met regularly to consider and discuss issues of contemporary life and culture.
At an earlier session, Wally had introduced T.S. Eliot to the group. In January
1954, given the platform, he made a public proclamation of his aesthetic credo.
He began by dividing the art world into three groups.

First, we have the "academicians." These men paint objects. . . but, to me, in a very
dry and impersonal way. They never paint themselves into the world and, as a result, it
is hard to tell one canvas from another except by the subject matter. . . . When you look
at one of these paintings you feel aesthetically parched. They always remind me of W.C.
Fields' description of his trip across the alcoholically dry state of Kansas when he said,
"For days I lived on nothing but food and water."

Second, we have the "middle-of-the-road moderns." These men also give us "objects," but treated in a far more personal way. You can tell the canvases apart because the imprint of the artist himself is on them. Thus, it is easy to say, at some distance, without reference to subject matter, "There is a McFee, a Mattson, a Derain, or Segonzac," because of highly developed individual style. These men take all that is good from both past and present, and fuse it into a personal point of view.

Third, we have the "extreme modernists" or so-called avant-garde or abstractionists. Here we rarely find objects depicted at all but are given instead merely a combination of lines, shapes, and colors calculated to give us some emotion in themselves. These artists owe little to the past and often boast of it, insisting that they seek "new directions." This is the group that wins most of the prizes and is shown greatly to the exclusion of the other two in our museums throughout the country. . . .

Now please don't misunderstand me. I believe in modern painting. Anyone who has walked through the brown school rooms of the old masters in a museum and then entered a room of good moderns knows the upsurging of blood pressure one feels with the impact of fresh color. I realize that we can't go on living in the past and that the artist must have freedom to work in any medium in almost any way, and I know that great paintings may have a certain amount of distortion; but, I believe that there is a point or line beyond which we cannot go. When we stop representing objects and substitute for them merely a combination of lines, shapes, and colors that have nothing to do with life of the world around us, I insist that this is not painting but, at best is mere decoration and should be labeled as such. . . .

Wally looked at the audience of prosperous St. Louisans, the city's leaders, and knew that he voiced for them their confusion and frustration with modern art. His actor's heart quickened. He blasted the deification of accident, formlessness, and self-indulgence; he questioned the practices of galleries and dealers in promoting false goods; he lamented the power of critics to put laurels on charlatans; and he sympathized with confused viewers who wondered "is this art?" or "what's this supposed to be?"

Wally's performance, rooted deeply in the defeat he still felt from New York, ended to enthusiastic audience approval. The men who heard Wally told their wives and friends about the sensible, down-to-earth rebuttal of modern art that they had heard.

Kelse, who had heard the talk in practice sessions, was not surprised by the response. She was pleased by the complimentary telephone calls from friends and the cheering remarks from women she met casually as she shopped about town.

The Round Table printed and distributed the popular speech. Years later, at the celebration of Wally's eighty-second birthday, St. Louisans remembered and toasted again the talk Wally gave to The Round Table.

As the excitement from the speech wore down, Wally turned full force to painting again. In talking to the men of The Round Table, he had talked to himself. He had posed questions about the nature of art and form.

As Wally delved deeper into the mysteries of form, into the components of composition, into the building blocks of painting, he separated his professional life into two distinct areas: the private world of the studio and the public world

of exhibition. While protecting the sanctity of the studio, he also sought public recognition for his work through exhibitions. With friends, he formed the Painters' Gallery, a cooperative gallery in St. Louis, to show work and to encourage recognition of work by St. Louis artists. In addition, he showed his work in Paris, in New York, and in San Francisco.

But exhibition troubled Wally. He looked around, read art magazines, and fought against bitter anger that his own work gained less attention than he thought it deserved, while the work of those he considered charlatans was praised publicly. Notoriety is not a substitute for fame. Clark Gable, as he has said, could be notorious; Rembrandt was famous. And only God could make a tree.

Charles Moreau-Vauthier wrote a guide for both artist and audience to promote understanding of certain principles of appreciation. This companion—in most aspects a silly book standing on uncertain but pompous pinnings—lived in Wally's studio. Hefted, Wally's copy of this outdated and frail book falls open to a passage that he apparently turned to often for comfort: "Public exhibition put a premium on charlatanry. How is an artist to attract attention among the crowd of competitors? The submission which was formerly a condition of success is now considered a hindrance and a confession of impotence. Tradition is despised. The artist must be independent and prove it and attract attention."[3]

Wally, zestful in theatrics, balked at charlatanry. In dubbing himself artist, he had married tradition. Painting in the light of the masters—if not actually painting for them—he often assumed an apologetic stance, stepped back, rubbed out a stroke or passage that might have seemed impudent in their august company. So long as he persisted in this appenticeship, self-imposed and by no means without merit, he would tend to understate, to self-mock, and to avoid the attention he needed as an artist and longed to gain.

Just as Wally's book on technique and theory obligingly falls open to reiterate its message to Wally, so does his paint-stained and hard-used biography of Vuillard. Wally's identification with Vuillard turns in a paragraph that readily leaps forward:

His dread of risk, his slender appetite for adventure, barred the way, necessarily, to other discoveries. He penetrated ever deeper and deeper into his own being, always in the same direction. Resignation this might be called—more truly, it might be recognized as his fidelity, a virtue illustrating his life as well as his art, his devotion to the same beings, the same objects, the same sites. This unswerving loyalty is to be wondered at in a time when shock value, and ambition laudable in itself and respected by him, to break with the already seen and the already known—to astonish oneself—had impelled so many artists along a perilous course.[4]

Wally set his sights on the long view and thereby partially and reluctantly resigned himself to the shadows of obscurity, shadows which would be only temporary, he believed. In faith, then, he plowed forward with renewed concentration and dedication to his views of traditional painting.

3. Charles Moreau-Vauthier, *The Technique of Painting*, p. 62 (New York: G. P. Putnam's Sons, 1928).

4. Claud Roger Marx, *Vuillard, His Life and Work*, p. 41 (London: Paul Elek, 1946).

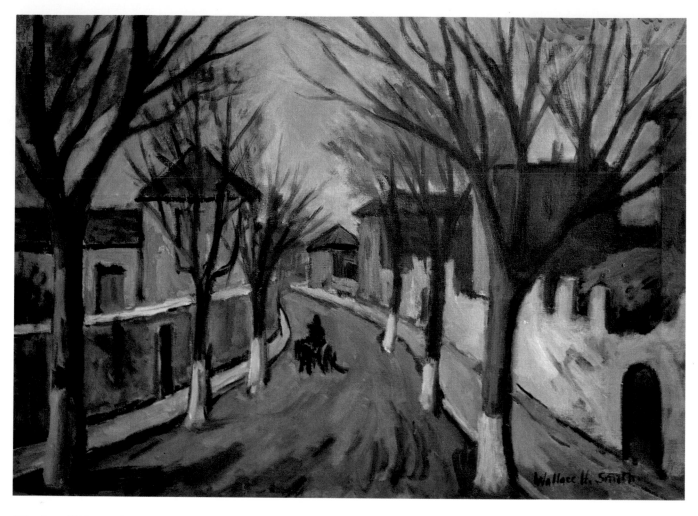

22. *Small Town in France,* 1950s oil on canvas, 21″ × 29″

In the summer of 1950, Wally and Kelse returned to Europe for the first time since they left in 1928. It was to be a grand time, fancy free; an adventure to regain youthful ebullience in their middle years. Kelse would have opportunity to flex her French, a language that she adored and in which she maintained fluency by continually reading in French and by weekly participation in French conversation groups. Wally, less proficient in the language, loved the French countryside, the charm of the lazy village streets, the grandeur and mysteries of Paris.

Between 1950 and 1975, Kelse and Wally traveled almost annually to Europe or to Mexico or to some other attractive region. Typically, as Kelse slept late, Wally prowled the streets, sketched, took photographs, stopped for coffee or a casual chat in a cafe or coffee shop or dive. Whether sketching or photographing, whether talking with shopkeepers or passersby, Wally let his eye roam, follow contours, absorb shadows, delineate buildings; and as he observed, he transformed

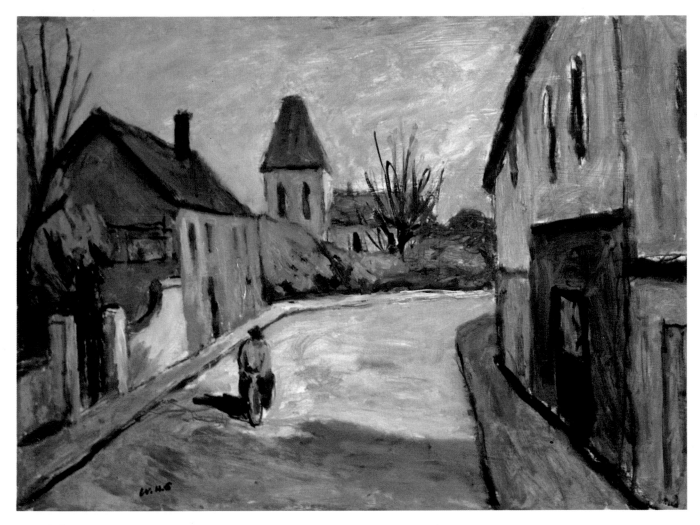

23. *Cyclist, France, 1950s* oil on artist board, 21″ × 29″

observations, he subjected visual data to the conceptualizing treatment of the human mind. It is the process by which an artist puts his particular print upon experience; it is the source and essence of style. And, finally, the discipline—the habit or tropism—of observing and transforming all visible experience is the basic activity of the creative mind, the lifespring of visual art. No artist comes pure to the virginal canvas; no artist observes visual phenomena in a completely detached manner. Artists, like everyone else, carry considerable emotional baggage formed from a collection of previous experiences. All visualization is symbolization; all symbolization is the process of forming emotion; all forming is a mental process for finding or assigning meaning to human experience.

What emotional and symbolic baggage did Wally, now in his sixties, carry as he walked European streets, as he looked at buildings, as he talked with people, as he observed sunlight and shadow, as he watched riverflow and cloud movement?

*A village in South Central France, 1950,
photographed for Wally's archives of
subject matter during the Smiths' first
visit to France since leaving Paris in 1928*

Throughout his career as an artist, he had measured experience to a degree by tenets developed in architecture and theater. Similarly, he assessed the effectiveness of painting techniques—movement of brush, liquidity of color, handling of paint, buildup of color, definition of tone, linear and massive treatment of composition—on an eclectic scale, never fully articulated, born of his love for French modernists and for the old masters. Whether consciously or not, he criticized his own and others' painting in terms he had learned from these sources.

The scenes of small towns that Wally constructed resemble only in part those identifiable with Utrillo, de Chirico, or Hopper. Utrillo used the convenience of buildings and street intersections to handle paint; to leave a visual record of his action in moving paint across an area, causing a color or tone to invade the domain of another, and allowing one edge of paint to shoulder into another with a range of suggested feelings from hostility to cozy-snuggling. De Chirico, on the contrary, strains the building facades and echoing empty streets of his work through a film of distilled sunlight, a light so pure that it never was seen but only imagined, in order to establish a dreamworld of emotional super-reality. While Utrillo hooks the attention of the viewer in the sensuality of the paint itself, and holds that viewer on those physical points, de Chirico negates the materiality, the substance, or paint in order to draw the viewer into the madness and mystery of shared dreams. Each, in his way, leaves the viewer free (under sentence of compulsion) to collaborate on setting the meaning, the personal meaning, of the experience with the painting.

Hopper, unlike either of the European painters mentioned, applies sunlight to the particularity of a building or urban scene. Empty Sunday mornings in forgotten, insignificant backstreets of urban America; or street-lighted, isolated moments of abandoned urban night; or incongruous buildings tenanting awkwardly or provisionally an inhospitable fragment of nature—these are the sets and feeling-tones of Hopper.

As Wally collected visual data, the raw material, for his cityscapes, he followed precisely none of the paths laid out by Utrillo or de Chirico or Hopper. The recreated world of his cityscapes does not provide a field for him to lick his chops over the delights of paint-as-substance, nor to establish a super-reality that promises an ultimate encounter with truth, nor to scrutinize particularity, isolated, so as to reveal universality.

Yet, he incorporates a modicum of each ingredient: delight in the nature of paint itself and in the act of painting; an aloofness and detachment akin to reverie or dreaming; and a metaphorical statement about the estate of humanity.

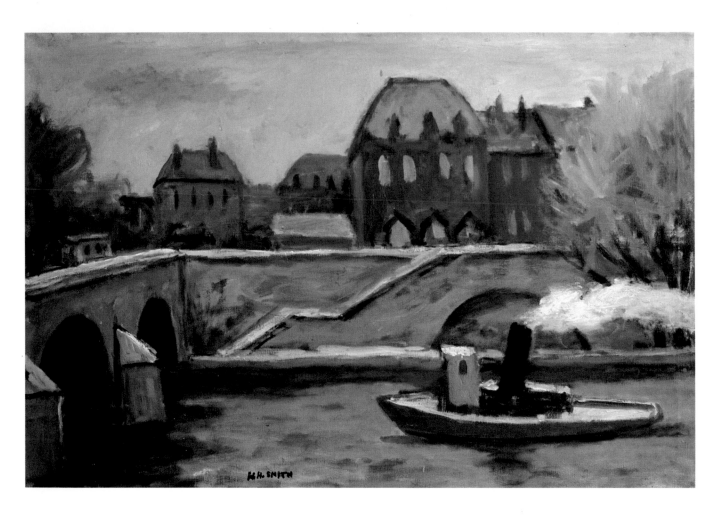

24. *Paris, the Seine with Tug,* 1960s oil on canvas, 24″ × 36″

T. S. Eliot wrote in *The Love Song of J. Alfred Prufrock:*

> Let us go then, you and I
> When the evening is spread out against the sky
> Like a patient etherized upon a table;
> Let us go, through certain half-deserted streets,
> The muttering retreats
> Of restless nights in one-night cheap hotels
> And sawdust restaurants with oyster-shells:
> Streets that follow like a tedious argument
> Of insidious intent
> To lead you to an overwhelming question . . .
> Oh, do not ask, "What is it?"
> Let us go and make our visit.

Eliot's verse could be invoked to describe the cityscapes (finally the paintscapes) of Utrillo, de Chirico, Hopper, or Wallace Smith. All are theater of the mind, arenas of the emotions visiting, through reverie-freed empathy, the established in paint, the given, and the inevitable: the unconscious patient is helpless; so is the perceiving mind, with its surface film of practical consciousness etherized, turned alone onto the streets menaced by unseen, unidentifiable forces that could be threats or rewards. These are the places of people, the scenes constructed by people and then abandoned; the cast-off shells of contained human life into which one stumbles, receptors open to feeling. Can one ever feel as isolated and abandoned in the natural world as in the artificial world that has been constructed by and for human beings, a world which conspires to isolate and baffle the beings it fails to serve?

Wally had painted streets, as he had painted people and still life and water, throughout his career as an artist but, in the years that he and Kelse renewed their foreign travels, he found in the emptied street scenes (he, I believe, emptied them; he did not often find them actually empty) a symbol for the human condition, much like the symbol that he would find in his sailing paintings and his river paintings—a complicated, multi-layered symbol that defies (as real symbols are required to do) summation or decoding.

> Oh, do not ask "What is it?"
> Let us go and make our visit.

In general, Wally's cityscapes incorporate a street or streets, whose existence is arbitrary and whose beginnings and ends are unknown. The streets are flanked by buildings whose facades and planes vise-grip space which, so held and compressed, becomes substantial and therefore architectural.

The light washed over the planes of Wally's cityscapes is theatrical but not at full saturation. The curtain has only just gone up on these sets, these stages of controlled space; the light is not yet fully bright; action, which may be withheld, has not yet begun. Anticipation invites anxiety as desire beckons disappointment.

Inaction becomes action on these stages. The artist, not succumbing to the temptation of formulaic and mindless color-bursts, withholds from the viewer's grasp one set of expected experiences. Can an artist seriously set up a cityscape, build walls of paint, and not act out the familiar role, not speak the lines so thoroughly loved by the public, of impressionism (French or American flavor, no matter)?

Why forego this sensual pleasure? Why deny the viewer this expected delight? The impressionist treatment of paint—like the culinary possibilities of the oyster—may have posed difficulties for someone, sometime. But now? Hardly. Impressionism (and its many rip-offs and fastfood variants) can, with agenting by museums and artists, soon be yet another vaudeville act; like the Mona Lisa, it is in the process of being appropriated by the greeting card industry.

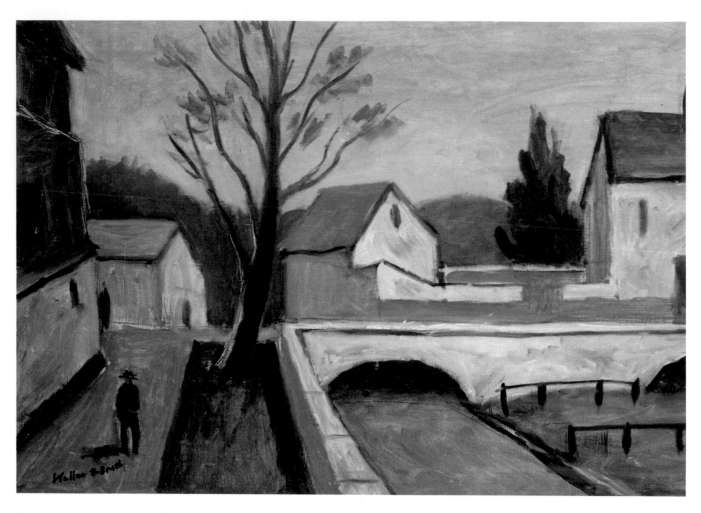

25. *Autumn Scene with Canal,* **late 1950s** oil on canvas, 21″ × 29″

Wally, along with Utrillo, de Chirico, and Hopper, chose not to seduce the viewer with the too familiar, with the already understood. Risking personal and professional isolation—unwilled solitude—these painters turned to the subject of isolation as irony and metaphor.

Speaking to the Harbor Springs Kiwanis Club, Wally theorized about art.

A painting is not like a piece of machinery except that it is finely put together. [It is] put together not to function in any practical way but to elevate us, give us an emotional thrill, satisfy an inherent need in us which is a desire to contemplate beauty. When I worked in an airplane factory I was told [that the work] must be extremely exact. [I] worked to [a] tolerance of one one-thousandth of an inch. Tolerance in art is far finer. What is a painting? There are many definitions. To me it has to do with the coming together of beautifully calculated lines, forms, and color to represent objects and make an harmonious whole that excites and stimulates the beholder because of its finer adjustments. It is not a copy of nature or of objects. Nature is only the keyboard upon which the artist plays. He cannot bang indiscriminately but must select and choose beautiful chords or he will produce only dissonance. . . .

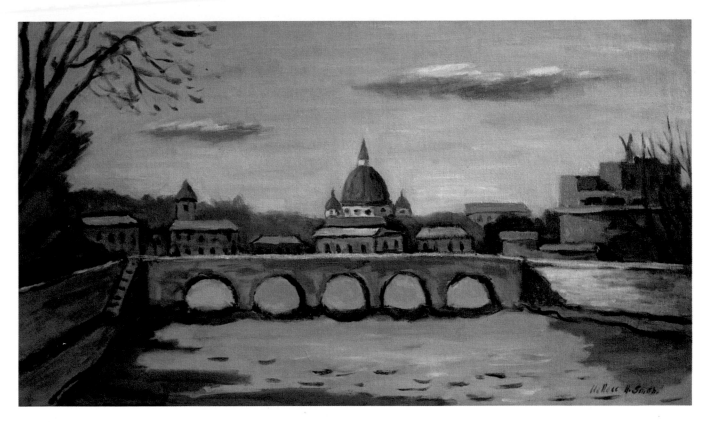

26. *The Tiber,* 1950s oil on canvas, 19″ × 33″

I don't believe we can intellectualize art too much in an endeavor to appreciate [it] because the works themselves were not created that way or for that type of appreciation. Renoir said he painted as the bird sings. Let's try to breathe in the result and enjoy it the way we do a beautiful melody. . . .

The only way I know of to learn to enjoy paintings is by going to the museums time and time again. Record your impressions if you want. Watch your tastes change and develop. When you see one of Degas' ballet dancers you will begin to feel the beautiful grace in her gesture. The glorious color of the sets behind her and how everything is so simplified and restrained that [Degas'] feeling and emotion before the subject is easily grasped by you yourself.

From the notes of his speech that survive we can reconstruct and almost hear his argument: painting is a pursuit of beauty; the beholder may be challenged or stretched to apprehend beauty in a given painting but, on balance, the painting must be so constructed as to allow an eventual view of beauty.

An unwritten law, perhaps an extension of Wally's Protestant ethic lingers here: an artist is constrained by honor to play fair, to put forth honestly the yield of his searches, to share the fruits of his talent with his fellow beings. Talent, after all, belongs to the species; an artist is given stewardship over a portion of the total store. From him to whom much is given, much is expected.

On the whole, Wally's view of art makes his painting (and more advanced painting as well) understandable to the members of the Harbor Springs Kiwanis Club along with anyone else who might be interested enough to devote a little attention, a little time, a little caring to the process of looking and thinking. Wally, in effect, outlines the house rules for collaboration between artist and audience.

Wally's mode of work, though private, parallels his public requirements for art, artist, and audience. He searches and, finding intimations of beauty (or order or form) beneath the surface of a given subject, uses his talent and skills to reveal that beauty in a painting.

Searching through Europe, he found subjects for his work. For example, he claims an early morning scene (pl. 19) along the Seine near Les Invalides. He watched a horse lazily pull a milk wagon along a pale morning street. Working the scene into a painting, he emphasized the circular planting areas out of which the trees grew and their relationship to the cartwheels. Architecture assumes a dominant theme, at once backdrop for the action of his fabricated stage and actor on his fabricated stage. The flat-faced line of shops juxtaposed with the dome rising at the center of the background set the pace and tone of the painting.

In another picture, *Cart on French Street* (pl. 20), Wally blurs the cart and lets the architecture contain and define the cart's direction. Here the architecture, with varied coloration and shape, provides the mood and the action in the painting. It is a drama of architecture. When he paints *Chartres* (pl. 21), the great cathedral stands on a stage suggested by the top of the wall at the front of the painting which poses as the front edge of the stage.

Other actors will be permitted to play roles in the drama of architecture that Wally fabricates and controls in his paintings. In a picture of a *Small Town in France* (pl. 22), the curving street with no discernible destination save a mystery behind the curve, around a bend, becomes an architectural element in league with the walls that mark its edges and the trees that stand between those walls and the roadway. The trees and the cart and figure at the center of the painting are stylized sufficiently to be compatible with the definite lines and solid masses of architecture.

In another view of a small town in France (pl. 23), a cyclist pedals toward the frontal plane of the painting but he is, again, wholly contained within and defined by the presence of architecture. He is no more and no less human than is the tug (pl. 24) that pulls its trail of smoke in front of Parisian architecture, that chugs along an architecturally conceived Seine.

While Wally was actually observing the scenes of France in summer when trees were at full foliage, he took the liberty of stripping a tree of its leaves (pl. 25) so as to prevent the interference of a green mass with the architecture or with the theme of the painting, *Autumn Scene with Canal*. The figure, again a bit player, establishes scale of the architectural mass in the way a coin might in a photograph of an archaeological object. The painting, then, grows from actual observation

but the observations, the recollected sensations, the hard data of the photographs, are transformed by Wally's imagination.

He dealt almost literally, almost factually, with *The Tiber* (pl. 26), but even in that treatment of an architectural monument—a hard and abiding triumph of architecture—recollected in tranquility, he elects to emphasize the underlying drama of the architecture so that the surface of the Tiber serves as a stage on which the Castel San Angelo and St. Peter's stand.

Wally's sallies into transforming architecture and observed scenes into paintings, of turning architecture and other sense-data into drama, led him to look again at the familiar church and Main Street of his beloved Harbor Springs. *Church at Harbor Springs* (pl. 27), a painting of this period, viewed frontally, is an erect spire flanked by tall trees that stand as if they were smaller spires on side aisles.

Harbor Springs' Main Street (pl. 28) spreads stagelike before the rising spire of the Holy Childhood of Jesus Church; it is flanked by small town American buildings which echo the little shop buildings of France. The specific buildings in Harbor Springs are identifiable as, presumably, the specific buildings in France and Italy are identifiable, but the emphasis is on their simplicity and mass, their plastic position in space, and their ability to evoke and embody emotion on their own. There are, to be sure, the minor characters of two horses and a buggy with driver and of two people standing on the street corner, but the people and horses are character actors, bit players, to the greater drama established by the presence of the architecture.

Even nature itself acquired new animus for Wally in the fifties. The earlier paintings of woods in Michigan had suggested Wally's identificaion of the shadowy paths with the great interior spaces of cathedral but in the early (1956) painting of the shore, *Dunes and Pine Trees* (pl. 29), he made gestures toward the existing natural phenomena, the details of foliage, the specific juts of land and singular hillocks. Later, emboldened by his studies to make architectural elements in his paintings both more dramatic and more simple, he unhesitatingly let reverie call forth his treatment of the same dunes and pine trees, this time seen in *Michigan Moonlight* (pl. 30).

In *Self-Portrait with Pipe* (pl. 31), Wally looks closely at his physical self. He is no longer young. Never conventionally handsome, always a bit tousled, at mid-life he sees himself as a bit jowly, biting down hard on his curved pipe, a curve that incidentally repeats the curve of his nose. His face, as presented in his self-portrait, could break into rounding laughter or could slump toward despair; it is held in tension between the two.

In his portrait of Kelse (pl. 32) from the same period, he observes his spouse and friend as she dreams, looking away from him in an almost profile view. Her fine dark hair beginning to grey maintains its vibrant sweep back and upward into a slightly disheveled line. She sits quietly, head thrust slightly forward; she is calm and thoughtful.

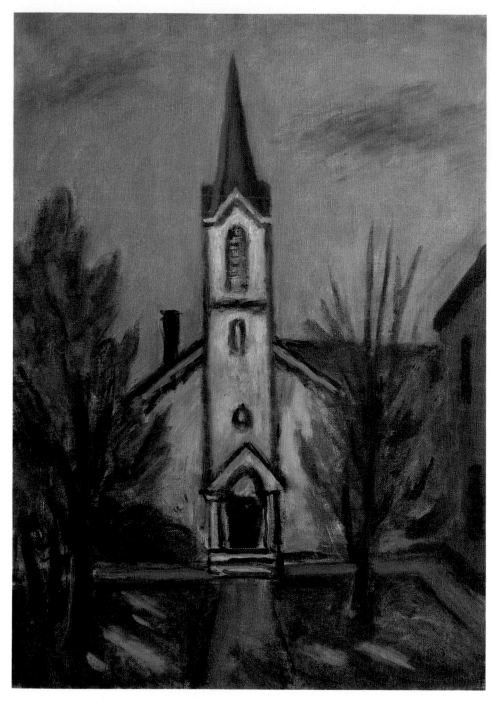

27. *Church at Harbor Springs,* 1950s oil on canvas, 24" × 17"

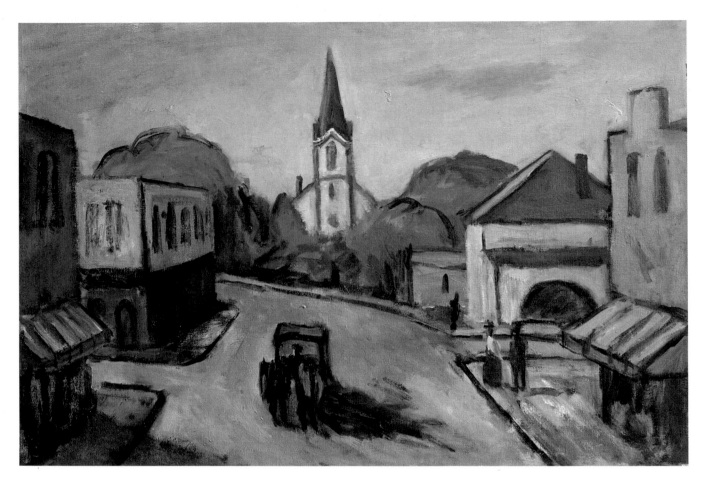

28. *Two Horse Town*, late 1950s oil on artist board, 23″ × 29″

On a visit to Maine, he painted Peggy Bacon (pl. 33), whose steady encouragement, sharp and amusing wit, and eye for painting had sustained and invigorated him over the years. Peggy sits as if listening thoughtfully to an unseen guest, smoking, slightly detached and relaxed. Surrounded by pictures and a view of the sea, her well-shaped head and good demeanor are reiterated by Wally, as if he is reminding himself of Peggy's eternal qualities and her gift for graceful attention.

These portraits of the fifties, however, are the personal musings of an artist checking out his touchstones, testing his anchors. He admits to aging, to time passing, to change, but in the portraits he affirms the sturdy stuff of friendship and love. Having thus assured himself of the security of friend and wife, of Peggy and Kelse, he begins to step cautiously toward a new era in his painting.

As Wally wrestled with his own demons in his studio, he also set out to win in the world of art galleries and museums a place for his finished paintings. Thirty years of painting and of the hopes and disappointments associated with exhibition left Wally with confidence in his work; he believed he represented beauty to the best of his ability; he believed others could comprehend that beauty as he reconstructed it on the surface of his canvas and masonite panels. Why, then, did serious critical acclaim escape him so persistently?

In October 1953, Wally's exhibition in Paris was received with mixed reviews as reported in the *St. Louis Post Dispatch:*

Arts, a Parisian weekly devoted to the arts, commented: "His still lifes, portraits, and landscapes reveal a palette of diverse and subtle color. More freedom of conception and more daring in carrying out such ideas, however, would make this methodically sure painter an artist."

Combat, a leftist and often anti-American newspaper, reported on the exhibition: "This American's paintings possess all the characteristics of a conscientious art.construction, solid composition, attractive subject matter and delicate harmony of grays and browns. The latter sometimes recall the work of Marquet."

The review concluded, however, with misgivings about the work: "There is missing . . . the spark that would give these works a life and personality."[5]

5. By Barrett McGurn, a writer for the *Herald Tribune,* special to the *St. Louis Post Dispatch,* October 6, 1953.

Two chords were struck in the criticism of Wally's paintings at the exhibition in Paris that would be sounded throughout the years. First, he was compared to Marquet. Second, a reviewer before Wally's self-effacing work, often subdued in color, found a lack of excitement in the paintings. By the fifties, public appetite for the outrageous in art was whetted. Viewers who went looking for thrills of affront would be met instead by Wally's implaccable, understated rehearsal of tradition; but the viewer without preconceived requirements might meet in Wally's work a reassuring quality that in itself is startling.

The comparison to Marquet stands. There are similarities. But, taken as a whole, Wally's work has affinity also with other artists—with Vuillard, Brook, Hopper, for instance—or, looked at another way, with no one else at all. His singularity derives, however, not from the splash and razzle-dazzle that characterize work attracting attention in this period. His work exists not to excite or as evidence of excitement, but rather as calm reflection on life as formed by art through the ages; a longstanding apprenticeship to the masters who live in the attic of his mind, shut away in protection and perhaps embarassment, funny relatives best not paraded before the neighbors.

In the early years of the fifties, George McCue, art critic for the *St. Louis Post Dispatch,* turned a thoughtful eye and a learned sensibility on Wally's paintings. McCue, an enthusiastic lover of paintings, consistently risked having his writing labelled romantic in order to talk about the feelings that paintings engendered in him. In 1951, McCue chronicled: "Wallace Herndon Smith, whose paintings have

been exhibited in one-man shows in New York and Paris but have never before been given such treatment in St. Louis, has finally accomplished it."

McCue referred to an exhibition at the Artists' Gallery, continuing his attempt to place Wally in the art world of the time:

Smith is an unabashed, uncorruptible, conservative painter, a role he has happily occupied since he discontinued his earlier profession—architecture—in 1932. Smith uses a rather low-key palette in which earth colors and soft grays are much in evidence. The paintings on view are largely landscapes, nocturnes, portraits and views of the sea made on visits to France, Italy, and the Smiths' summer resort in Michigan.[6]

6. *St. Louis Post Dispatch*, March 3, 1951.

McCue noted especially the effectiveness of *Woman in White*, a very simple composition of a seated female figure, posed with her back to the viewer. Jane (Zeekie) Pettus bought the painting from Wally even though it was unfinished. Later, however, looking at the elegant picture in the Pettus home, Wally agreed with Zeekie that further painting would have lessened the force of the picture.

In 1953, Wally showed his work in Paris at the galleries Bernheim Jeune. This event, celebrated merrily among his St. Louis friends, was the subject of a special report to the *St. Louis Post Dispatch:* "This solo display in the world's art capital, dream of artists everywhere, was arranged by Maurice Serullaz, an official of the Louvre Museum. Serullaz, himself a painter, much admired Smith's work that he saw in St. Louisans' homes during his visit here last January for the City Art Museum showing of French Drawing."[7] The article continues with reference to Wally's "restraint and subtlety" and notes that his work often was described as French in tone and nature.

7. *St. Louis Post Dispatch*, September 14, 1953.

The exhibition was well received in France, perhaps because the work had indeed a very French flavor and presented no discomfort for the French viewers. Moreover, the French government acquired a painting, *Snow in Clayton*, from the show.

By the end of the decade, in 1959, Wally showed his work at the California Palace of the Legion of Honor, an event again heralded in a special report from San Francisco to the *St. Louis Post Dispatch:*

In the art life of this area, Smith's paintings strike an unusual note—not because they are up-to-date or original, but for an opposite reason.

San Francisco and its art-minded suburbs now average 20 to 40 exhibits a month, winter and summer. The most prevalent tenet of the exhibits—with certain stubborn exceptions—is that art is more meaningful when it is abstract or very nearly abstract.

By the modish local standards, therefore, Smith is both eclectic and conservative. Conservative tastes here will find a fair amount in him to approve, fashionable tastes will not.[8]

8. *St. Louis Post Dispatch*, February 1, 1959.

The article, continuing, compared Wally's work to that of Marquet and Brook, his old teacher, and to Utrillo and Marsden Hartley.

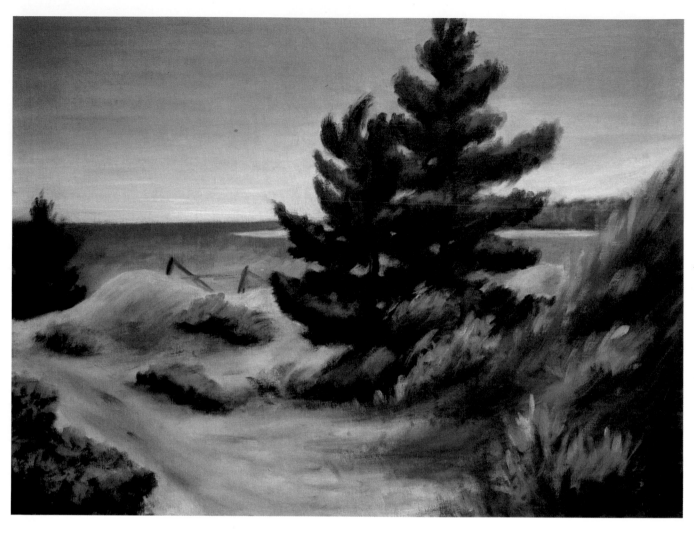

29. *Dunes and Pine Trees*, 1956 oil on canvas, 27″ × 36″

By the end of the decade, Wally had earned an unfashionable position as a conservative and an eclectic. He did not deny these labels but, rather, took the aggregated description as complimentary, as small evidence that he served loyally his standard bearers.

As he painted and exhibited in his middle years, Wally hardened the lines between his private life as a painter and his public life as entertainer and bon vivant. In degree, everyone is emotionally secretive and, one way or another, everyone has secrets of the heart that require husbanding. Wally could not speak seriously, publicly, of the depth of his feeling for painting, of his private imaginary conversations with Cézanne, Renoir, Vuillard, and others. While as entertainer he often invited laughter at himself, he did not want his core-self seared by mocking laughter. He would joke about himself as an artist (notably in such paintings as *The Mediocre Specimen*, a self-portrait owned by his friend, Joseph

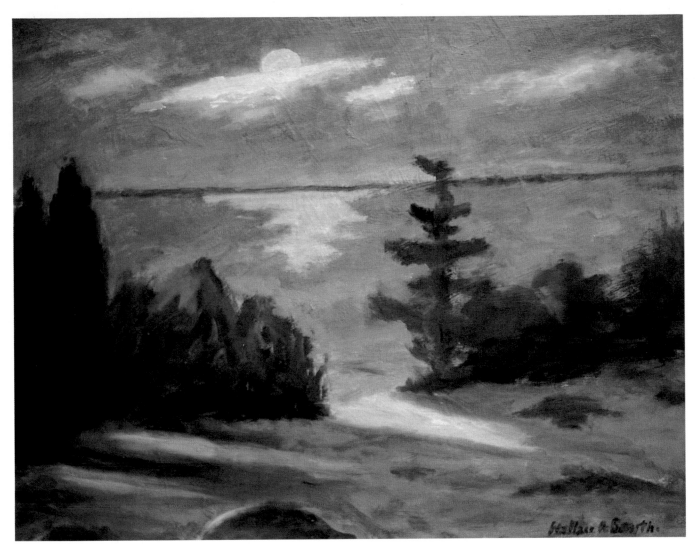

30. *Michigan Moonlight*, early 1960s oil on artist board, 24″ × 31″

Pulitzer), but he placed the jokes as curtains, even fortresses, around real, protected feelings.

Wally did not want to own up publicly to his passion for painting: in New York, faced with the rough and tumble world of art, he had chosen to abdicate the position he had claimed and to return to the security and familiarity of St. Louis. In St. Louis, confronted in the privacy of his studio with the irrevocable nature of talent and, more potently, of the drives that attend talent, he painted against the shadows of anxiety, uncertainty, and fear. Who, after all, knows his *Moirai*, knows for certain that he is an artist and can therefore sustain the public mauling that goes with the territory? What passes in our view of art history for courage or conviction may well be, artist by artist, a sense of inevitability, an acceptance of doing what must be done, of simply acting out the only script at hand.

Since the Second World War, Wally had to come to terms with the despair that can only confront the adult, the human being certain of time passing and certain, too, of his own mortality and the tragedy and comedy of humanity. He was not entirely equipped by education or proclivity to wrestle with these very serious demons. He had no one to guide him, no close friend in whom to confide.

Toward the end of the 1950s, Wally returned to France with his eyes prepared by the intervening years of painting French monuments and scenes to look again, with a driving and searching gaze, at Notre Dame and at Mont St. Michel. As an artist he was prepared by the analysis and painstaking looking over the years, his perception aerated and tilled by reflection and by continual painting of the subjects. How he hungered for some blazing vision of exactitude, of rightness, of finality.

Wally returned to France this time as a pilgrim, not as a playboy on holiday and in pursuit of lost or dimly remembered pleasures. As a pilgrim, stripped of frivolity regarding the process of painting, he was finely tuned to his own needs to know from the ancient monuments of art something of the eternal truths of the discipline. He occupied perilous psychological territory.

In the humbling nimbus that surrounds a pilgrim's search, he went with mature eyes and bare soul to the great monuments of *Notre Dame* (pl. 34) and *Mont St. Michel* (pl. 35). He walked their paths, felt the coolness of their shadows, saw them from distances and close at hand. He let their masses take form in his consciousness, felt them reach from their deep roots in France's bedrock to the spires that thrust toward God. In his fifties, Wally had grown up, had stepped off the Triangle Club stage in his secretest self. In putting away some of his childhood expectations, he ceased to see as a child and he ceased to feel as a child. In the last years of the 1950s, he synthesized a variety of forces that had long hovered in his mind and studio. He brought drawing and painting into an affinity that had eluded him in previous works; he made peace with color as a component of tone; he learned the discipline of focusing his memory on experience in order to simplify, organize, and represent experience. He understood, at last, what Ryder had meant when he wrote: "The artist should fear to become the slave of detail. He should strive to express his thought and not the surface of it. What avails a storm cloud, accurate in form and color, if the storm is not therein?"[9]

9. Albert Pinkham Ryder, "Paragraphs from the Studio of a Recluse," *Broadway Magazine*, 14 (September 1905), pp. 10–11A.

Wally, for the first time, was able to concentrate wholly on the monuments before him, to let the monuments enter his thinking and his vision in a direct and unalloyed stab of truthfulness. He photographed Notre Dame from all aspects. He walked inside and outside. He climbed the towers. He sat across the river, half-dreaming, and let the great church fill his entire awareness. At Mont St. Michel, continuing to photograph, he walked the perimeters of the island fortress-church, climbed the long and difficult path to the cloister, gave his consciousness to the hush and mystery of the great building.

When he returned to St. Louis, Wally painted the summation of his experiences, his inchoate certainties of the nature and truth of the churches. The paintings, constructed of similar tonalities, present simplified but majestic images. Each edifice stands, like a lonely aging heroic actor, on stage, towering over all other minor figures and each, against somber sky, rises from a stage suggested by river wall or seawall. These paintings, continuing the simplified and directly powerful architectural elements, have the presence of great brooding soliloquies delivered by aging actors cloaked in mortality. These are not the groping paintings of a boy artist, they are fully realized masterworks.

Fred Conway

St. Louis, a mellowed city with graceful residues of an earlier time in its architecture and slightly curving streets, remains small enough so that people know each other. A number of artists, some of them quite good, worked in and around St. Louis. Most of them were friends. Wally, always gregarious, managed to know virtually all of St. Louis' artists. Over the years he had acknowledged, along with the other artists of his natal city, the stature of Fred Conway. Conway, among his peers, was recognized as a serious, talented, vastly skilled, artist-teacher. Wally and Conway had exchanged quips, nodded agreement toward one another's paintings over the years.

When Wally's paintings—his need to paint—fully contained his mind, when he was reconciled to his servitude to painting, he and Fred Conway saw each other anew. By the early 1960s, Wally was certain enough of himself as an artist to seek out Fred Conway and to offer friendship. Conway, for his part, was delighted to share Wally's liquor and humor, genuinely impressed by Wally's painting, and as hungry for companionship as Wally. The two men became fast friends. They recognized in each other more than shared wit, more than shared bitterness about the direction of the art world; each saw in the other a familiar passion for painting and a desperate need to mask that passion with jokes and other forms of public posturing. They became a team; their attachment lasted until Conway's death in 1973.

Wally called Conway "Sweetheart" and Conway nicknamed Wally "Rosebud." Thus, Sweetheart and Rosebud entertained each other and a circle of friends with a patter of jokes and with playful, often self-mocking, banter.

Fred Conway, a native of St. Louis who was orphaned as a boy, studied art at Washington University and then in Paris. In 1924, full of French attitudes about painting, he returned to Washington University to teach and remained on the faculty until his retirement in 1970. Respected for his talent, honored as a teacher, and enjoyed as a foul-mouthed tease and storyteller, a ribald player of jokes, and as a drinking crony, Conway held center stage as the painter of St. Louis.

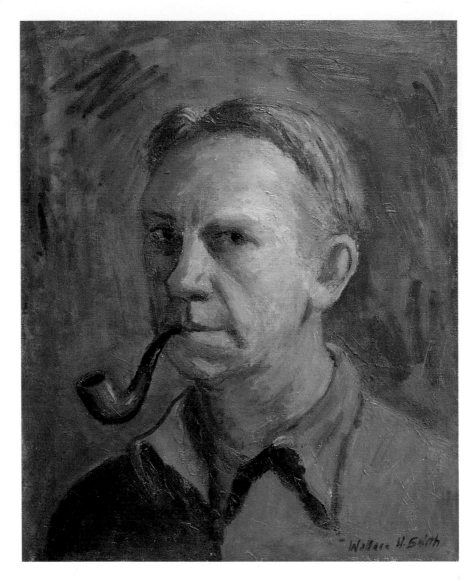

31. *Self-Portrait with Pipe,* 1950s oil on canvas, 22″ × 18″

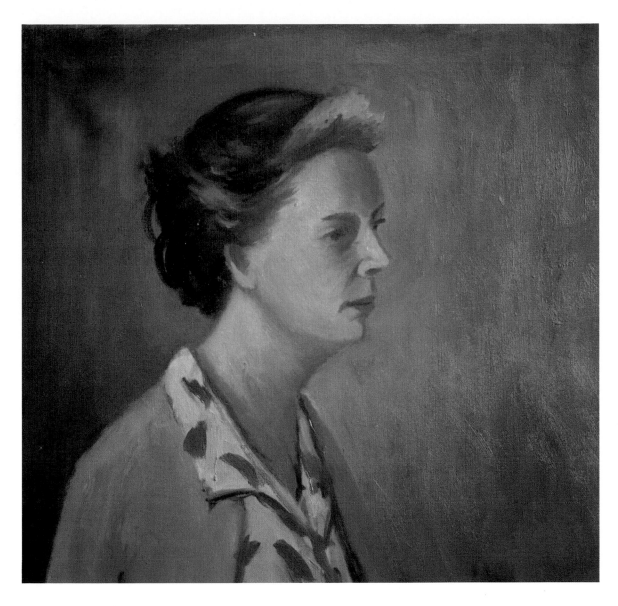

32. *Portrait of Kelse*, 1950s oil on canvas, 29″ × 21″

Conway, Zeekie Pettus, and Wallace Smith had founded the Painters' Gallery, which was incorporated by its thirteen members. The founders sold keys to the gallery for amounts ranging from one hundred to five hundred dollars, each amount serving as an advance toward the purchase of a work by a member. The idea of the gallery, born in conversation among Wally, Zeekie, and Fred, caught for a time the imagination of the St. Louis art community. The shows, selected and installed by the artists, attracted visitors; some works were sold; the gallery incited talk about art and about St. Louis artists.

Encouraged by the success of the gallery, Wally served as president of the St. Louis Artists' Guild and, in that capacity, took an active public role in the life of art in St. Louis. In these public expressions of concern for art, Wally was encouraged by Conway.

It was the personality of Conway, not the public activities in the St. Louis art world, that fueled Wally's energies as he absorbed the lessons he had taught himself during the fifties.

Both Conway and Wally talked and joked incessantly. They alternated between taking turns, topping insult and one-liners with put-down and pun, and simply talking simultaneously, non-stop, as if attended fully by a large and appreciative audience. Along the selvages between the drinking sprees and the jokefests, they found time and place for serious talk about art. They loved each other and never tired of mutually criticizing their work.

Wally fretted about not exhibiting, about being unknown. Conway pushed aside the concern with his high whinnying laugh and then affectionately lectured Wally: "There are endless opportunities to make it these days—most of the younger painters teach. They go on and get degrees; they exhibit. We never thought of having an exhibit. If we did, we figured we'd be lucky if our mothers came to see it. I was the only one of my class who was called back to teach."

Then, drawing a bottle of bourbon from behind a junk heap that had been a still life setup, Conway continued, more seriously: "Unless you're one of those rare ones who has been touched by the hand of god, you've just got to work like hell."

"Yeah," acknowledged Wally, taking two well-smudged glasses from the defunct still life, "Pour out our work and let's get on with it."

Wally and Conway set up elaborate plans for sketching expeditions, for watercolor sessions together indoors or outdoors. Kelse, skeptical of the actual work accomplished, thought that drinking, more than watercolors, absorbed the men's attentions.

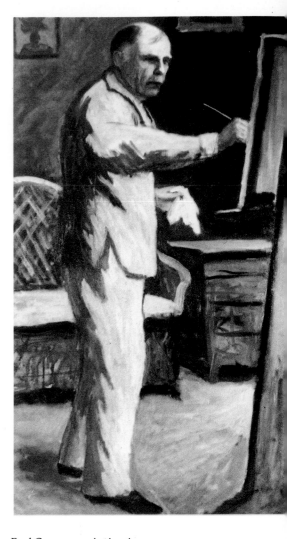

Fred Conway, painting in Wally's Michigan studio

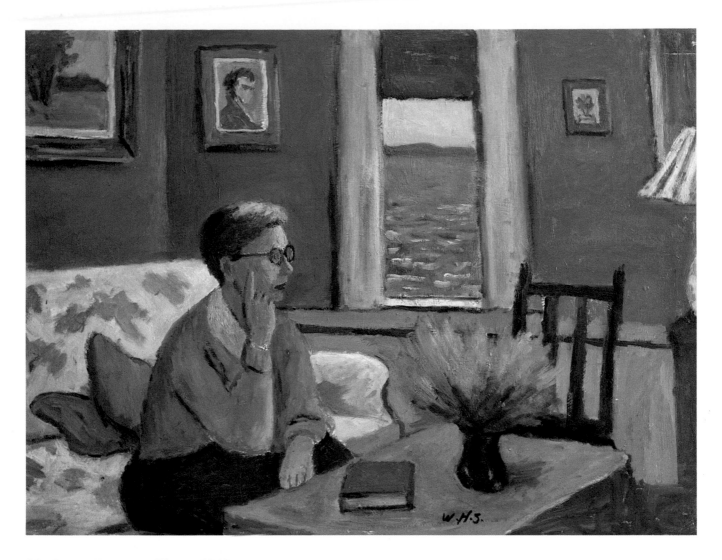

33. *Peggy Bacon at Home,* 1960s oil on canvas, 21″ × 29″

In actual practice, both drinking and painting were served, sometimes one more than the other. "Watercolor! Here's to it!" toasted Wally as he held a glass of whiskey to the sunlight in Michigan.

"When you do a watercolor," countered Fred Conway, "there's no second-guessing. That's where an artist shows his fingerprints. With an oil, you can go back and correct your mistakes and repair and patch and do things over. With a watercolor," he paused to drink, "there's no second chance. It's all attack and no retreat."

"Charge!" retorted Wally.

A Community of Artists, 1960

As Wally approached his sixth decade, he worked steadily. He had no way of knowing that the 1960s would bring him some of the benefits he had been seeking: he would find friends and community in art and he would achieve more recognition as an artist.

In 1961, the Norton Gallery in Palm Beach produced a one man show of Wally's work. He was elated. Kelse found the installation of the work elegant; here, she thought, people could see well the subtleties of tone and color that informed Wally's paintings.

Wally bought beautifully carved wooden Barbizon frames in France and shipped them to St. Louis whenever he could find them. Kelse sometimes thought he loved the frames so much that he wanted to fit his pictures to their aesthetic tones but she agreed with Wally that they were right for his paintings, that they softly embraced the images, that they established well the spaces and emotional qualities of the work.

He used his Barbizon frames in preparing the Norton Gallery show. He was pleased with the results: the show, in his judgment, was a zinger; a real show with fine light on the paintings.

He was surprised (though Kelse was not) when the works sold quickly: the show was indeed a sellout. The success of the exhibition in the Norton Gallery notwithstanding, Wally's greatest rewards as an artist issued from his membership in a group of St. Louis painters who thrived during the sixties.

Wally found the nucleus of the community of artists that he had sought since his earliest days in Paris. In the 1960s, his community expanded and, within a group of playful but vigorous painters, Wally shone as a leader, sometimes as a teacher, and as an artist.

Wally and his artist friends worked with Alice Langenberg on Friday mornings. Mrs. Langenberg, locally celebrated as a horsewoman and for civic leadership (especially in her role as administrator of the Children's Hospital), turned to painting at the age of seventy-five. She sparkled with energy and enthusiasm as she wholeheartedly turned her prodigious powers of will and her proclivity for order toward painting. Mrs. Langenberg could scarcely bridle her enthusiasm for art and she was not one to reckon with small coin as she invested in one of her projects. This characteristic set the tone for her practice of painting. She set up an elaborate studio with lights, screens that could be arranged to simulate a variety of settings, costumes, and props for use by models, and a variety of objects suitable for study in still life painting. Alice Langenberg's studio, splendid and complete in all aspects, delighted her so thoroughly that she wanted to share it with friends.

Wally, Alice's old and dependable friend, was invited to paint in the elaborately turned-out studio on Friday mornings. Soon, amidst the chatter and warmth of their own gregarious natures, they included other painters.

Alice, taking seriously her responsibilities and privileges as hostess, organized the painting sessions to begin promptly at ten o'clock. Models would be hired and draped; still life arrangements would be laid out and bathed in suitable light. The assembled artists worked, teased one another, offered and sought criticism and advice on techniques and materials. They took turns suggesting problems and teaching each other.

At twelve o'clock each Friday, Mrs. Langenberg's butler arrived in the studio with a vast picnic hamper filled with sandwiches, salads, sweets, fruits, cheeses, and delicacies that she had selected for the occasion. The butler opened the studio bar. From twelve o'clock until two each Friday afternoon, the artists drank and talked, argued, and encouraged one another.

The group included Zeekie Pettus and Louis La Beaume, Wally's chums of long standing. Kelse posed for the group several times. Soon Wally wanted to include his beloved Fred Conway but, concerned about the feelings of the hostess, he worried that Conway's foul language and bawdy ways might offend Alice Langenberg. On the other hand, he argued to himself, Conway would bring both presence as an artist and the skills and knowledge of a teacher to the weekly gatherings. One Friday, following an exuberant session of painting and the usual elegant picnic, Wally lingered for another drink with Alice.

Alice, to everyone's amazement save her own, had quickly grasped the fundamental issues of composition, had developed basic skills in the handling of oil paint, had learned to draw with a direct, simple, and very bold line. She loved everything about her new pursuit; loved the smell of turpentine as much as the intricacies of devising interesting still lifes. Wally encouraged her, offering quiet criticism and nudging advice which she received eagerly, gratefully. Their longstanding friendship expanded and was solidified further by their Friday painting sessions.

They talked for a while about Alice's paintings. Taking a page from Van Gogh's book, Alice had set for herself the problem of painting a chair by painting the spaces around it; by, in other words, exploring the negative space surrounding the positive solid object in order to depict more forcefully the essence of the object.

They sat before one of Alice's chair paintings. Wally looked at it carefully. "Alice," he suggested, "if you really want to make the lighter tones zing, you'll need to back them up, push them forward, with some white."

"Show me," she responded.

Together, they rubbed still-wet oil paint from surfaces and brushed in other tones; they extended the range of contrast as Wally had recommended and, to Alice's delight, they achieved the solid feeling that had eluded her previously.

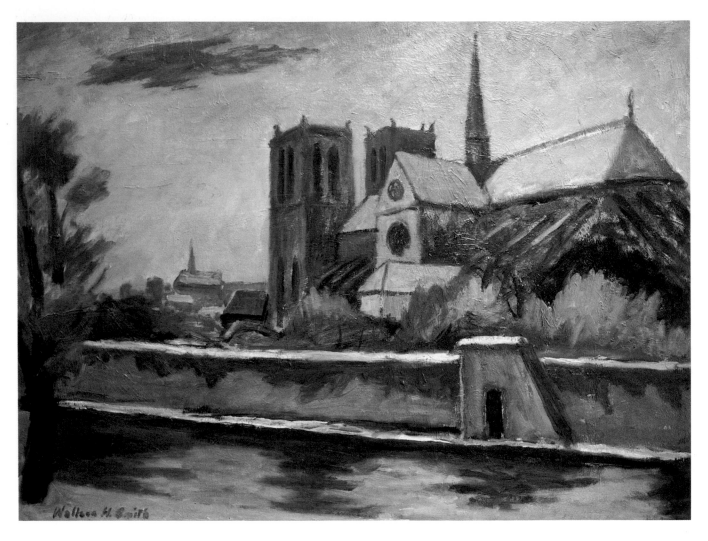

34. *Notre Dame,* late 1950s oil on artist board, 27" × 36"

As they had a celebratory drink together, Wally brought up the subject of Fred Conway and, specifically, of asking Fred to join their painting group. He explained to Alice that Fred, though the best imaginable friend and a wonderful artist, was given to coarse language.

"Nonsense," dismissed Alice. "By all means, invite him. What a wonderful addition to our atelier!"

Fred joined the group, half promising Wally to restrain his dirty talk. In the excitement of the group, however, Fred soon forgot his promises and turned to his usual scatological, blasphemous, and smutty forms of expression. Wally, after a time, believed that Alice Langenberg did not hear or understand Fred.

Alice, never acknowledging Fred's talk by so much as a blink of an eye, confided to her daughter-in-law, Mary, and her son, Oliver, that "Fred was an imp."

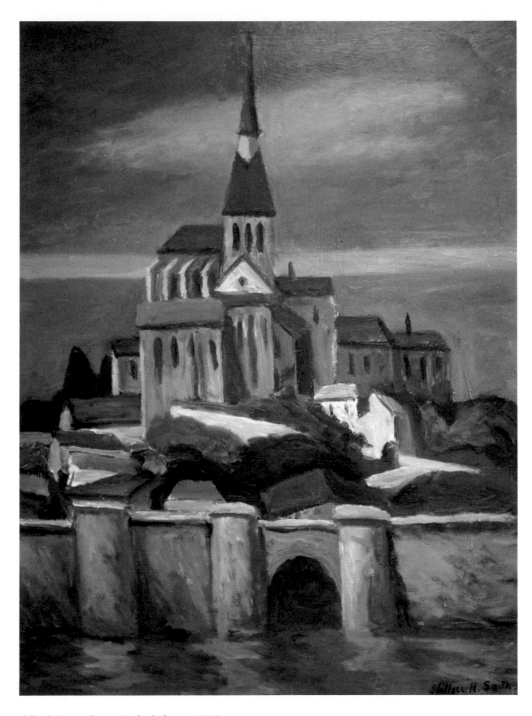

35. *Mont St. Michel*, late 1950s oil on artist board, 40″ × 30″

In their haven the sorcerers of St. Louis, these artists, found sanctuary. While they joked and shouted much abuse at one another—Fred never missed an opportunity for sexual or scatological allusion—they also worked. They created within their view of St. Louis, their own community of nonconformists and, thus energized, they turned to the still lifes and figure arrangements that were set before them.

A number of Wallace Smith's most carefully constructed and intellectually considered paintings resulted from these sessions in Alice Langenberg's studio. "My best work came from there," claims Wally.

In Alice Langenberg's studio, Wally returned with renewed discipline to still life painting. Wally and his friends, recreating themselves in their version of Bohemianism, set themselves up as students, as artists-learning-discipline through attention to the process by which paintings are made. They, in their actions, affirmed Robert Henri's opinion:

What a mistake we have made in life in seeking the finished product. The thing that is finished is dead. That is why the student interests me so. He is in the process of growth. He is experimenting; he is testing all his powers; he has no thought of any finished product in his expression. A thing that has the greatest expression of life itself however roughly it may be expressed is in reality the most finished work of art. A finished technique, without relation to life, is a piece of mechanics, it is not a work of art.[1]

1. Henri made these remarks in his review entitled "The New York Exhibition of Independent Artists," published in *Craftsman*, 18, 2 (1910), pp. 160–72.

Henri's statement could have served as the credo for Smith and his friends at Alice Langenberg's studio. There, amidst jocularity and zaniness, they worked to understand painting in its liveliest form. Still lifes, long recognized as an exercise for disciplining the artist's sense of form, occupied much of their Friday time. These affluent and cosmopolitan St. Louisans, working together at Alice Langenberg's well-appointed studio, quipping and gossiping, criticizing work, and talking continually about art they had seen on their travels, formed the nucleus of a school of painting. Looking for inspiration and guidance in techniques, they cosseted French influences while artists elsewhere in the United States tended to follow New York's leadership.

Wally found in still life painting a means for extending the lessons he had learned in architectural training, lessons he had incorporated into his paintings of cityscapes and of buildings. Trained as a beaux arts architect to value drawing and, furthermore, to value drawing as a means for describing exactly and precisely the placement of mass, the interaction of form, and, finally, the way a building would, should, could, did occupy space, Wally rarely drew in order to merely describe objects, scenes, or people before him. His work, save for a few actual portraits, evolves instead from his abiding interest in underlying formal relationships, in design, and in the permutations of material through which an artist re-orders sensation.

Despite the analytical and formal nature of still life, it allows an artist a dimension of expression exactly consonant with his own sensibility. Wally often uses still life whimsically, not so much for the substance of analysis, not so much as the doorway or means by which to analyze a painting. Rather, he uses still life conventions as the stepping-off point for making his own paintings, as the launching pad for personal and emotional reflection and for the exploration of mass in space.

In three still lifes from the late 1960s, Wally combined his flair for playfulness with his ability to employ the rudiments of architectural analysis of form in order to give presence and power to painting. *Yellow Still Life* (pl. 36), resulting from Wally's dashing playfulness and his flirtation with Matisse, reached a point of existence or completeness without being overlaid with a look of conventional finish. True to Henri's creed, he experimented with space and color, tested the vibrancy of tone against tone, and did not overly work the painting. The effect of overall liveliness and sunny good cheer pleased him.

Fred Conway looked at the work a long time. Silently. Nudging Wally, he nodded and smiled. "Not half bad, Rosebud." Wally understood the measure of Conway's praise. "Aw, shucks, Sweetheart," he replied, curtseying theatrically.

"Where one or two painters are gathered," Smith often reminded Conway, "there's always a fifth." They settled before the painting to drink and talk.

Still life painting affords particular opportunity, even challenge, to an artist who wants to explore the formal elements of painting under the guise of dealing with recognizable, everyday objects. Whether composed of fabric, vases, flower, fruit, or other bits and pieces of domesticity or of more esoteric objects, still life, as it resides on an artist's set table, exists because the artist put it there, put each object in its particular place and in special, specific relationship to other objects. Further, still life exists because an artist chose to arrange objects in anticipation of looking at those objects, their colors, their shapes, their forms, the spaces between them, as the subject of a painting. Finally, still life exists because a painter transforms to a two-dimensional surface the actual objects he has arranged to find his vision; he makes a painting of a scene he has made. In such complicated works as *Bouquet* (pl. 37), Smith acknowledges his debt to Matisse and Dutch still life painters at once.

The process of painting still life is a process of transmuting objects to subject. In this respect, it is an essential act of painting, pure in its abstract purposes and synthesizing in its intellectual dimensions. Thus, it is also a revealing aspect of the nature of painting as art in that it requires an artist to deal with a highly controlled situation which is, simultaneously, a situation comprised of accrued choices.

No clouds pass serendipitously to cast unwanted shadows. Cows do not suddenly heed the green of a distant meadow and move themselves in its direction. Flowers neither nod beneath zephyr nor break beneath rain. The sun never sets on a still life.

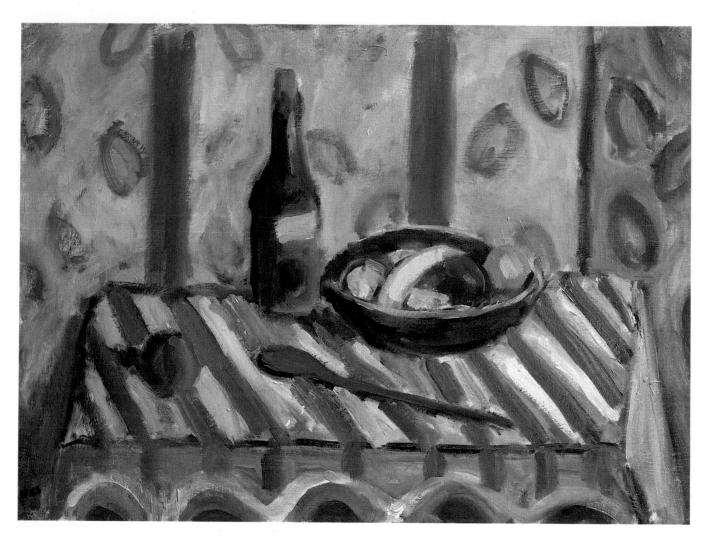

36. *Yellow Still Life*, late 1960s oil on canvas, 21″ × 29″

Moreover, the vases and apples and fabrics of a still life, unlike a human model, do not shift by breathing or by puffing from inner joy. The objects of a still life hold still. The life is what an artist adds, the tensions he assigns, the allusions he insinuates, or the symbols he bares.

As identifiable pursuits, both landscape painting and still lifes came late to the history of painting. Their prototypes appear, of course, in fragments, edges, fringes, little corners loved only by artists in manuscript painting or in the early panel paintings during the childhood of painting as a form.

Still life probably reached its maturity in the hands and minds of the great Dutch artists. These proud materialists, these happy keepers of and traders in things, were particularly suited to celebrate the form and, therefore, the life of objects found in the home. They used still life as the vehicle for transforming the material

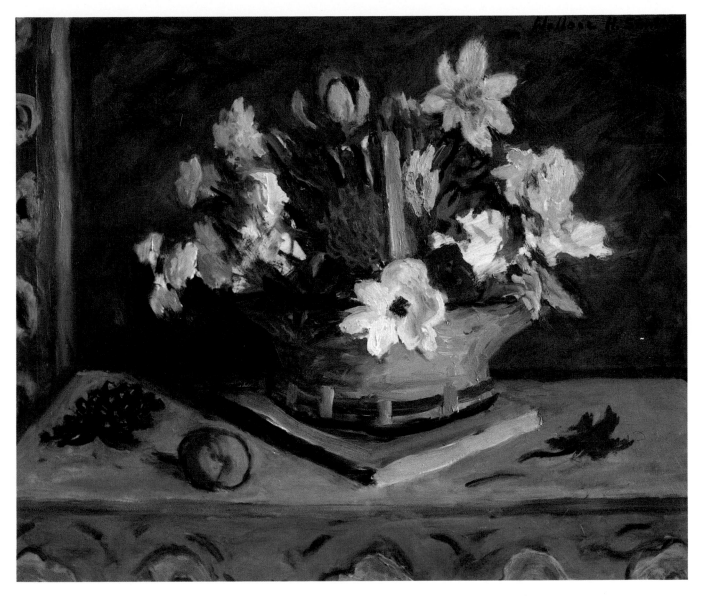

37. *Bouquet*, 1970 private collection, oil on artist board, 24″ × 29″

substance of daily life into intellectually precise and emotionally constant treatments of form.

Modern still life artists, artists of the magnitude of Cézanne, Braque, Picasso, and Matisse, have used still life as the study room, the laboratory, the experimental station necessary to their overall exploration of painting. Cézanne's famous apples allowed him, no less than did Mont Sainte-Victoire, to consider the nature of space, the profundity of mass, the fatal necessity of air as arbiter of form.

In still life, Matisse employed decorative caprice to find personal iconography. Still life, with its analytical requirements, sustained both Braque and Picasso as they found cubism.

Wally, never completely comfortable with the mainstream tenets of modernism, selected and employed aspects of modernist still life paintings in his overall domestic view. In *Flowers in the Cottage* (pl. 38)—the family's Lake Michigan shore cottage in Harbor Springs—he extends the idea or purpose of still life to include the surrounding space of the cottage interior.

Kelse's Chair (pl. 39) is as much a still life as a painting of the interior of the Smith cottage in Michigan. Not only the arrangements of the furniture and the treatment of the surfaces indicate kinship with still life but also the use of other paintings as objects within a controlled space. The specific paintings, *Michigan September* (pl. 40), which hangs over the fireplace, and *Moonlight Sail* (pl. 41), which is shown behind Kelse's chair, are restated with the same formal detachment that Wally would employ when looking at and placing in a still life any other object.

The Langenberg group, in their role as students-in-perpetuity, attacked the figure with the same zeal that they gave to the still life compositions. Wally, never as certain of the figure as subject matter as of the architecture of inanimate objects, plunged into the studies nonetheless and produced both portraits and studio figure studies.

In November of 1965, Wally and Conway mounted a joint exhibition of their paintings at the Painters' Gallery. Fred's works, familiar in subject and attitude to a larger audience in St. Louis than Wally's work, drew approval from the local critic:

> Conway is full of mood and personality; he cuts up, tells anecdotes, gets sentimental. There are the familiar themes of gold and cityscapes and landmarks.[2]

2. *St. Louis Post Dispatch,* November 3, 1965.

Wally, for the same critic, was seen as "consistently dry and objective" and, moreover, Wally was deemed drab in comparison to Conway:

> Smith, who ignores developments in painting for the last 75 years, sticks to a no-nonsense appearance of reality. He seems to be interested in rendering what he sees in a straightforward way, no French brushwork, no sophisticated notions of space or invention, no ingratiating color, no special effects. If this results in a certain drab integrity, it is achieved at considerable cost.[3]

3. *Ibid.*

The critic, a younger writer whose sights concentrated almost exclusively on new and advanced work, saw Wally's paintings superficially at best. Rather than a "no-nonsense appearance of reality," Wally's pictures presented greatly simplified and abstractly organized transformations of reality; almost all of Wally's paintings' surfaces seemed to agitate slightly under his pronounced French brushwork; and his "notions of space" were very sophisticated and subtle indeed.

This review, with its fabric of preconceptions, typifies the critical treatment Wally expected and generally received as a mature painter. More than ever, he was out of step with his age and, more than ever, he was turning to the traditional painters he admired for confirmation of his aesthetic values.

Wally admired the way in which Fred Conway taught his students at Washington University and admired, too, Conway's ready wit and keen intelligence in championing art to an uninformed public. Fred, Wally believed, was unable to make a bad judgment about art: Wally trusted Fred's eye and criticism totally. In one case, that trust may have been a mistake.

Fred and Wally set out to tour portions of the Mississippi and Meramec rivers on "Golden Arrow," a miniature sternwheeler owned by a friend. They pushed the small boat into the bends and currents of the rivers during the days; and at night, they docked to sleep, drink, and eat. Whether cruising or at anchor, they sketched and painted.

As they worked, Wally spread the planes of water on his canvas as if they were giant fabrics beneath a still life configuration. He placed objects—bridges, boats, even the steam from a boat's stack—on the surface as if they were portions of still life under scrutiny. But, despite the studied approach to the compositions, the paintings are lively, the color applied directly and at fuller brightness, higher key than was characteristic of Wally's paintings.

Wally enjoyed the paintings, enjoyed being on the rivers and being with Fred. His sense of pleasure and freedom colored the series of paintings, almost literally, for they are enthusiastically and directly executed paintings, not paintings wrested from analysis and reverie.

Fred Conway, reviewing Wally's work from the river trip, brutally denounced them. "These paintings, Rosebud, are sissy paintings, just too-too sweet." Wally winced as Fred added some colorful expletives about the origin of the paintings and about their physical properties. Ordinarily more encouraging and more attuned to Wally's work, Fred Conway's attack—possibly precipitated by the considerable boozing that the two painters had undertaken during their outing—cut Wally.

Kelse, charmed by the colors of the paintings, wanted Wally to frame some of them so that they might hang them in their home. But Wally, cast down by Fred's criticism, put the river paintings aside and hoped to forget about them. About twenty years later, they and a still later group on the same theme were found, stacked in a corner, faces to the wall, in the Smiths' basement in St. Louis.

At the time of rediscovery, Wally looked at the paintings. "These," he declared incredulously, "are among my best pictures. That was a good trip. Fred Conway and I worked all the time, all day every day, for about two weeks. Fred didn't much like these paintings, thought they were too light, too trivial, to tell the truth. But," mused Wally from the distance of time passed, "they're all right, don't you think?"

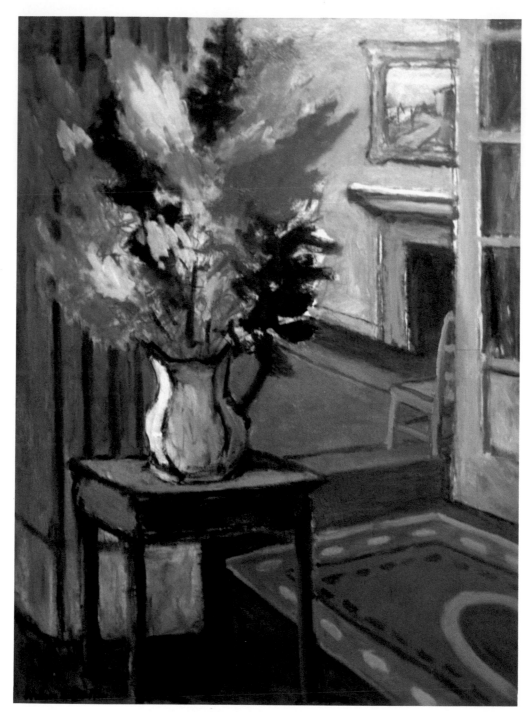

38. *Flowers in the Cottage,* **early 1970s** oil on artist board, 36" × 27"

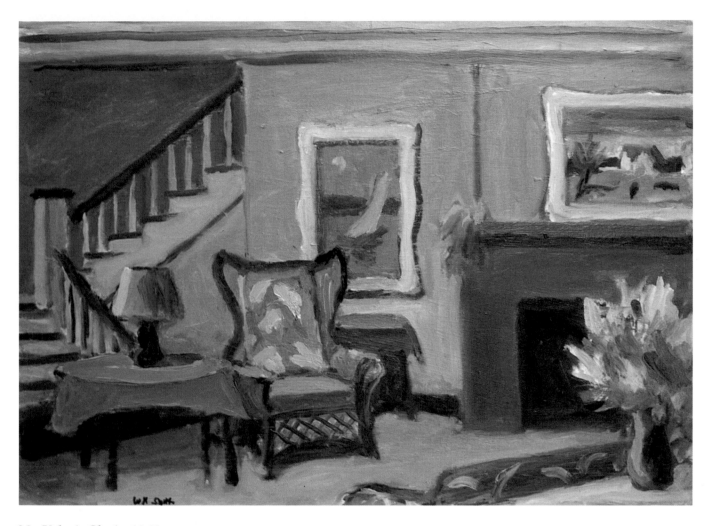

39. *Kelse's Chair*, 1960s oil on artist board, 15" × 29"

Immediately following the trip, Wally was haunted by the river paintings that he wanted to forget. In the next several months, he painted in secret several more in their overall tone. When, in 1971, he was offered a one-man show at the Frank Rehn Gallery in New York, despite Conway's evaluation of them, he included one of the second generation river paintings.

George McCue, one of many St. Louisans (including Fred Conway) who attended the opening of Wally's show, immediately spotted a river painting and wrote: "Smith's new paintings have gone up in key, and he makes freer use of arbitrary color than in the past works. His previous rather even and well-modulated light has become more highly charged, and is made a positive element in his designs, with emphasis on color contrasts."[4]

4. *Ibid.*

McCue noted that most of the paintings were predicated on French towns and Harbor Springs, but he observed, too, that one of the exhibited works, *The River*, "looking upstream from below MacArthur bridge. . . [shows] a stub of the Poplar Street Bridge and other similar landmarks under an unexpectedly violet sky and on a darker violet river."

Other critics did not remark on the exhibition of paintings. That, as always, depressed Wally. He did not return to the river series. They remain, however, as he was to remark after his eightieth birthday, among his best.

In *Mississippi River from the Meramec*, Wally sets in motion several elements which enliven the painting: the smoke from the stacks on the tug and from the stacks on land repeat a theme; the looping of the bridge echoes the shape of the wharf and, to a paler extent, the distant hills. These repeated flourishes serve to orchestrate rhythmic elements of composition. He continues, however, to rely heavily on his architectural standards for composition: here, for example, the bridge railing and the planes of the building underscore parallel themes; the color of the roof of the building relates easily to the color of the building to the right. The painting has a breezy quality that emanates from its directness and vigor in execution.

Similarly, *Mississippi River from the Tug* is born of high-hearted painting contained within carefully understood and realized composition, as seen in the manner by which the window of the tug emphasizes the edges of the painting surface and, in the process, enwraps the imagery of the painting. Horizons are defined and repeated by the city silhouette. A second boat repeats the major motif. The color is applied directly and forcefully; it is high in key and unbroken. Established by flippant, dashing drawing, the machinery on the tugboat in the lower central portion of the painting is an extension of the casual, playful, and direct manner in which the painting is realized.

Tug-on-the Mississippi, painted in warm but mostly muted colors, employs violets and yellows for both compositional and emotional causes. In composition, the violet is carried across the sky to reinforce the architectural form—the horizon band—of the painting; the yellow leaps over the rail and becomes the surface of the Mississippi in yet another permutation of repetition and variation.

In *Mississippi River from Window of Riverboat,* a painting very likely executed directly from observation while Wally stood in the cabin of the boat, draws the theatrical curtains aside as if to reveal his landscape of truth, the riverscape of eternity. In this painting, as in all the river paintings, Wally uses motifs as elements for repetition and variation, a means for establishing rhythms and patterns within the presentation of a simplified version of an actual scene.

The directness of the painting, the boldness of the drawing and the warmth of the colors conspire to produce a painting of uncommonly high spirits.

During the years punctuated by weekly sessions in Alice Langenberg's studio, Wally completed a series of figure paintings which affirm his commitment to the tradition of painting.

The human figure occupies a venerated position in the history of art. Whether viewed as a reflection of universal beauty, the imperfect individual expression of the ideal and perfect abstract, or as a vehicle, an actor, for expressing or acting out emotion, the human figure has served artists well. Few artists survive their student days and their apprenticeships without venturing into the realm of figure studies.

The Regionalists often used the figure to illustrate, almost literally, the activities and attitudes, the political problems and issues of the citizens of their region. This aspect of Regionalism never appealed to Wally.

Despite the time that he spent on Fourteenth Street and regardless of his respect for such social-comment painters as Raphael Soyer, Wally chose to approach the figure in a different manner altogether. Save for a few models who caught his attention (his wife preeminently among them), he tended to regard the figures as studies, as objects to incorporate into yet another exercise of the still life concept.

In his painting, *Girl in Green Shawl* (pl. 42), finished in one session in the Langenberg studio, Wally looks from a psychological distance at a model enhanced by the green drapery supplied by Alice Langenberg and by contrived lighting: a set piece. The girl might as well be a vase or a piece of fruit; her value to Wally resides in her formal components. She occupies space. She is the raw material of composition.

In *Girl in Yellow Chair* (pl. 43), painted in Michigan during the following summer, while the lessons of Langenberg's studio remained fresh in his memory, Wally moved in closer on the subject, in order to view her as a specific person within a defined surrounding of water and distance and horizon, of draperies and a familiar yellow chair. She possesses specific features, but even so she is more important to the artist as a configuration of massed elements than as a human being. Cézanne, of course, had tired of his wife's fidgeting and substituted a dummy, a large rag doll for her: it made no difference to the completion of his anatomy lesson, which is, at once, a still life.

When Wally turned to portraiture, as he did in two especially notable instances during the sixties, he lessened the psychological distance between himself as observer and the sitter as observed; he acknowledged feeling for and knowledge of the sitter. In the portrait of Zeekie (pl. 44), he painted his lively, flirtatious fellow painter, Jane Pettus, wearing a prop hat supplied by Alice Langenberg. Known as Zeekie to her friends in St. Louis, Jane Pettus painted alongside Wally and Fred Conway for years, casting herself as the student of first one and then the other.

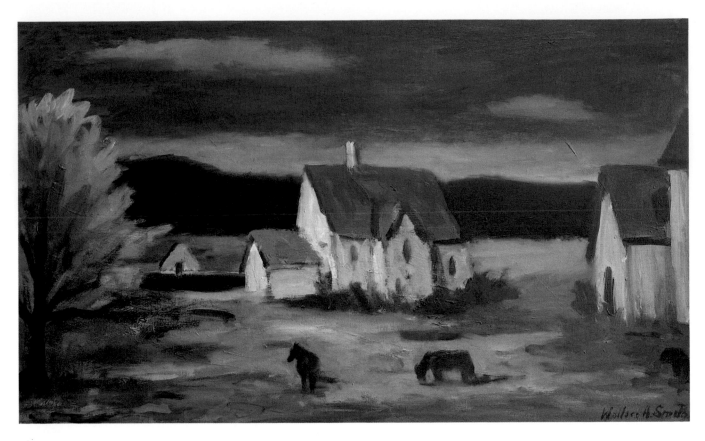

40. *Michigan September,* 1960s private collection, oil on canvas, 25″ × 41″

Wally casually introduced her to painting in his studio in Michigan where she was visiting. She was, in Wally's opinion, also chattering at him as he tried to work. He hoped to release himself from the grip of her conversation. "Go out and paint a picture for yourself," he ordered her. "Go paint a landscape."

Instead of a landscape, Zeekie painted a barn; Wally admitted readily that it was good, certainly good enough to spur her toward further painting. She quickly began to study with Wally, to draw as he directed her, to complete the exercises he established to help her learn to lay on color, to temper tone, to describe space and form within a flat surface. A quick student, she soon gained enough skill to work on equal footing with Wally and his friends, the other St. Louis painters.

Zeekie observed swiftly and drew deftly; she quickly gained hometown recognition and commissions as a portrait painter. In addition to the polished examinations of her fellow beings, so happily acknowledged among her admirers in St. Louis, she also painted landscapes of considerable power.

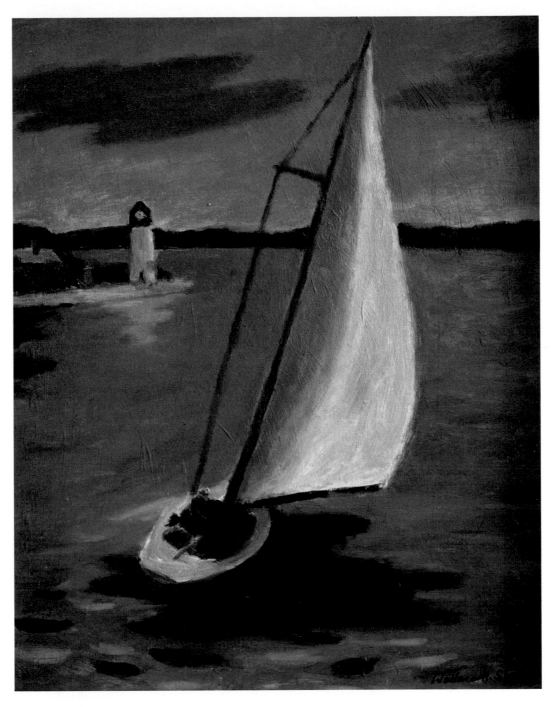

41. *Moonlight Sail*, early 1960s oil on artist board, 30″ × 25″

Fred Conway, a natural, even inevitable teacher, found Zeekie amusing and bright. He encouraged her through rough-guy talk, through outpourings of filthy language meant to both embarrass her and to recognize her as "one of the boys." She thrived on his treatment, to Conway's initial surprise and then comfortable delight. The three painters were fast friends.

In painting the vivacious Zeekie, Wally chose to look at her in a rare moment of immobility, of calm and serious demeanor. While he treated the hat as if it were a still life itself, he spent care on the modeling of the face and the treatment of the rakishly combed blond hair.

Wally's portrait of Fred Conway (pl. 45), like some of his portraits of Kelse and his full length picture of Jay, not only reflects the appearance of his subject but expresses his love and tenderness toward that person. Thus, like all good portraits, it reveals the mind of both sitter and artist.

Wally's uncommon friendship with Fred Conway, a relationship comprised of mutual loyalty and support that strengthened and enriched both men, obtained over a period of ten years or more. Despite Fred's cheering and invigorating presence, however, Wally struggled privately against his familiar old demons: why was his work not appreciated? How could he serve the masters?

In Harbor Springs, amidst the familiar jollity, festivities at the little Harbor Club, and the puffed-up sailing competitions that bracketed fast friendship with mock battles, Wally often found himself choking on loneliness. Silent and alone in his studio, he brooded. He leafed through art books. He fiddled with still life set-ups with artificial flowers. He drank.

Mostly he brooded.

He felt that he had lost his sense of purpose. Well, perhaps he had never had a purpose; perhaps he had been duped by his own childish belief in the Big Boys. In his sixties now, fervent about his work, what was he to do?

If Fred Conway served as friend-teacher, Robert Smith, Wally's brother, assumed the role (and some of the abuse that goes along with that role) of guardian angel. The chemistry between the men promoted a relationship of vigorous competition, of teasing and twitting. Despite the public verbal rough-housing, a brotherly love kept them close, afforded an understanding that surpassed words.

Robert, sensing Wally's turmoil and simultaneously believing without doubt in his brother's talent, stepped forth in the role of challenger-teacher. He was willing to fling up challenging obstacles to Wally and state the dare. "Listen, Wally," Bob said to his moping artist bother, "You're so interested in sailing, why don't you paint pictures of sailing?"

As boys, the two had always competed as sailors. Robert, the better and more dedicated of the two, honored sailing as a tradition of pitting mind and hand against the forces of nature, of working within those forces to bring about efficient speed at the most economical expenditure of energy. The force of nature and the grace of the human being inspired him as a sailor and he sought, in sailing, to bring about stylish maneuver while winning the race.

Ironically, Bob sailed as an artist, as a keeper of talent, and as a struggler against the unseeable and untameable forces of wind, water, and weather.

Wally, on the other hand, ignored the technical niceties of sailing. He preferred the hell-for-leather dash and excitement of sailing freeform, of not strapping himself within the confines of proven sailing strategies. Rather, freed of all but the most primitive skills, he confronted nature, manhandled his boat, and pledged passion against skill. While he sailed ardently, he sailed unconventionally, darting across lines or around buoys as he chose and not as regulations necessarily dictated. He crowded other sailors, shouted abuse and obscenity, joked, clowned, and swept others into his frenzy of self enjoyment or into fury and enmity.

Wally competed regularly with E.H. Steedman, a St. Louis social figure and a renowned sportsman, regarded widely as one of the best sailors in Harbor Springs. He was a challenge to Wally. He was also an accomplished, polished, by-the-book sailor, a man who honored the rules of sailing and planned strategies for winning around a solid knowledge of sailing, of boats, currents, winds, and weather.

Consistently, Wally challenged Steedman. Almost as consistently Wally lost. In losing, however, Wally invariably violated Steedman's sense of good sailing and, often, the rules of the yacht club as well. The near warfare that surrounded the on-going competition amused the summer colony. Wally, playing to the galleries in this summer theater, composed and recited a ditty at every opportunity:

> How I long for the bite
> Of a northern night
> In the land of lakes and Redman
> A windward run
> And when day is done
> A fight with E. H. Steedman.

Robert recognized the signs. The public entertainer, his artist brother, was in private anguish in direct proportion to his public display of foolishness. As he set out to amuse others, he set out to assuage his own pain. Robert hoped he might turn Wally's attention toward painting again, might renew or respark his zest for painting. And he knew that Wally would rise to the challenge.

Since his early adolescence in Harbor Springs, Wally had sailed. He loved sailing even though he loved it in a different key from that which marked Robert's love of sailing. Robert knew Wally's habits of mind and seamanship. When Robert challenged him to paint sailing, Wally's imagination did catch fire.

Under his brother's knowing and fond challenge, he painted a series of sailing pictures that allowed him to give expression to his talent and drive in painting as he had to his physical energies in sailing.

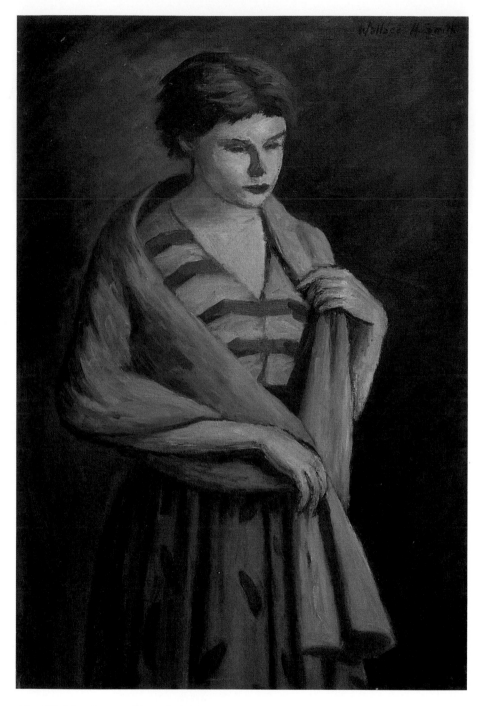

42. *Girl in Green Shawl*, 1960s oil on canvas, 36″ × 24″

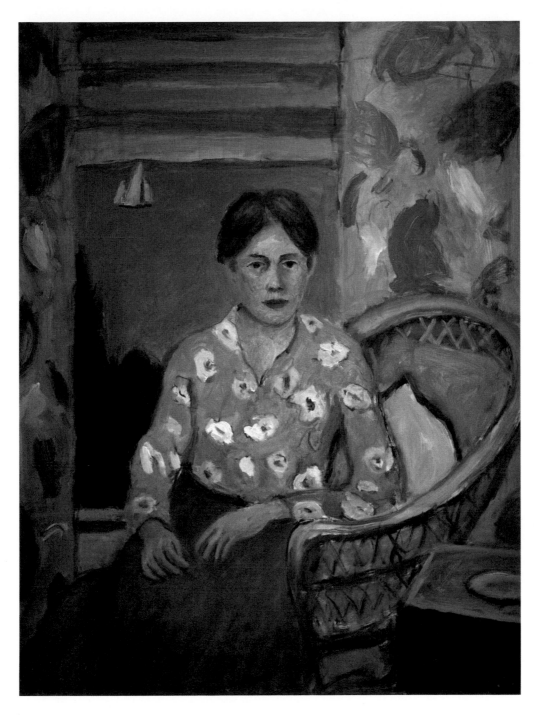

43. *Girl in Yellow Chair,* **early 1970s** oil on artist board, 36″ × 27″

These sailing pictures took on metaphorical significance. Sailing, that quiet and precise melding of technique and intuition, became a metaphor through which he could examine and form his deepest feelings. The journey through time and space, always a symbol of mortality, assumed greater poignancy if undertaken in sailing. Like Joshua Slocum, but symbolically through sailing pictures, Wally made his way alone around the world. "Give me boats and water," Wally prays. "Give me sailing if possible but give me boats and water under any circumstances."

Albert Pinkham Ryder wrote:

It is the first vision that counts. The artist has only to remain true to his dream and it will possess his work in such a manner that it will resemble the work of no other man— for no two visions are alike, and those who reach the heights have all toiled up steep mountains by a different route. To each has been revealed a different panorama.[5]

5. Ryder, *"Paragraphs from the Studio of a Recluse,"* pp.10–11.

Sailing as a subject was not unique to Wallace Smith. Other artists have painted sailboats, have recorded their awe for the sea and its weathers, have evoked the terrors and rhapsodies of sailing. Wally's sailing paintings acknowledge notable influences from masters who preceded him but, despite lessons learned before other painters' works, Wally's pictures, with their flirtation with naivete, further his personal vision.

Extraordinary American paintings about sailing include those brought forth by Fitz Hugh Lane, Albert Pinkham Ryder, and Winslow Homer. Lane's seascapes, with the minutely and precisely configured boats, stress equally the palpability of light and the substance of air and water as enlivened by light. Homer, too, gathered and intensified the instances of light on water and on boat; he reported both as well as the actuality of a specific time and place on the water. He painted his own sense of inherent drama as he observed the coexistence of boat and water. Ryder stripped down his observations, defined a scene and used the distilled elements to fabricate his own mysterious substance of life and death, of life as a lonely and perhaps unchartable journey over a vast sea toward an unknown destination.

Wally's boats are architectural, hard and three-dimensional, not the airy-fairy stuff of calendar sailing pictures. Wally's boats reflect exactly the proportions and design of the racing boats favored by the sailors on Lake Michigan or, in other instances, reveal just as definitely the characteristics of craft used by sailors in other places at other times—Cape Cod, Stonington, Boca Grande, or various places in Europe. Even so, his boats, like the settings of sky and sea in which they exist, are not encumbered with obliterating detail; they get by with just enough detail to set character and identity. They heel against the sea, are driven by soft or fierce winds; they exist as solid objects between a solid sky and a solid sea. Indeed, the energy of Wally's paintings does not derive from his depiction or reporting of sailing events so much as from his imagination and his emotional responses to such subjects as *North Wind* (pl. 46) or *Racing Sail Boats* (pl. 47).

In *Harbor Nocturne* (pl. 48), silent and solitary sailboats occupy the peaceful harbor. Neither human beings nor the rufflings of wind interrupt their dark vigil. This, too, is a painting of metaphorical proportion and intensity. In the dark night of the soul, watches are kept silently in the shadowy eternity of night, unpierced by beaconlight.

This theme, this metaphor, gives shape to loneliness and sadness. It sounds again in *Black Schooner* (pl. 49), in which the boats, in untouching communion with one another, assume the proportion of persona. As object-spirits, unwatched by human eye, the boats comport themselves according to dictates of order and silence beyond our ken. The artist, hushed but at close range, watches without fouling the perfect solitude and inescapable quiet of the scene.

Figures—people—who enter scenes painted by Smith usually do so at some risk for they appear without script and often serve compositional purposes more than narrative intentions. Sailors occupy some of Wally's boats (pls. 41 and 50), but they do not struggle to control the scene; they are along for the ride; they are contained in the boats' domain, and seemingly, they have given themselves over to the world of boats, sky, water.

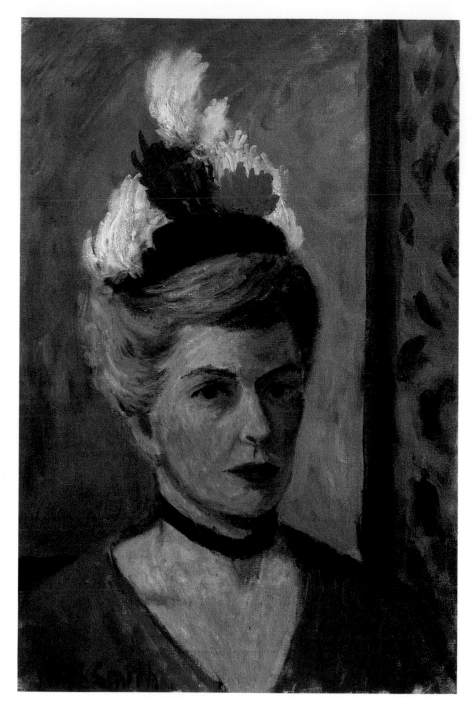

44. *Portrait of Zeekie,* 1960s oil on canvas, 16″ × 20″

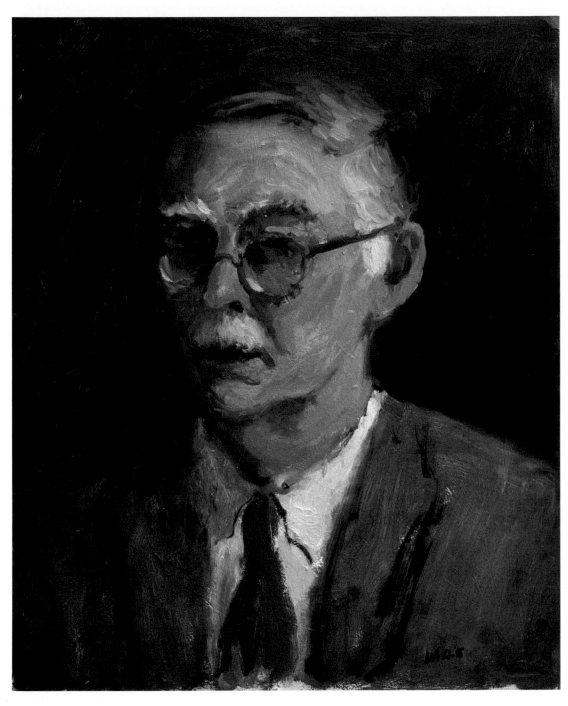

45. *Portrait of Fred Conway,* 1960s oil on artist board, 25″ × 20″

The Late Paintings, 1970s

Peggy Bacon joined Wally and Kelse for a trip to Bermuda in 1970. The aging friends, congenial and comfortable together, talked about their shared history. Peggy, once able to live on the sale of her work, had been swept into semi-obscurity by the revolution engendered by abstract expressionism. She settled into a modest cottage in the fishing village of Cape Porpoise, outside Kennebunkport, Maine, and, beside the sea, she worked on mixed-medium paintings. She often combined inks, gouache, and watercolors to produce luminosity akin to stained glass. Her subjects had become the houses and places around her in Maine and those remembered from her childhood in Connecticut. Peggy worked every day; she drew, she painted, she completed color studies necessary for particular paintings that occupied her interest.

Wally, who never enjoyed the fame and sales that had made evident Peggy's success as an artist, had also, he felt, been kept outside the art establishment by the monolithic attention to Abstract Expressionism that occupied the art world for several decades. He, like Peggy, had clung to the disciplines, the physical exercises, of being an artist. Each day he, too, worked: he sketched, he painted; he talked with Fred Conway about painting; he talked with Zeekie.

As Peggy and Wally sketched in Bermuda, their talk turned to the state of art in the world. With a touch of glee, they concluded that they had outlasted the tide of abstract expressionism. As they mentally surveyed the art world, they told each other that artists, in 1970, had scattered into their own personal encampments within experience, myth, literature, imagined symbolism of science, and that, under banners of their own making, they worked in whatever fashion they chose. Fine, they agreed.

As they explored the field of art that they laid out in their chat, they found artists to admire—Richard Diebenkorn, for example—and artists to continue to admire, artists who had managed to swim against the prevailing tides of the last two decades and to paint pictures that Peggy and Wally admired—their friend, Soyer, for instance.

The days in the sun, the conversations with Peggy, the jokes and stories, told and retold, with Kelse and Peggy in the soft Bermuda evenings invigorated Wally. He returned to St. Louis with new energies to apply to ideas taking shape about paintings.

Wally and Kelse had traveled in Mexico during the 1950s. Wally now pawed through his slide trays, flashed on the screen in his studio the images he had captured on film in Mexico. He set against his paint-spattered easel an earlier painting of Mexico, *Guanajuato* (pl. 51).

For several weeks, almost by habit, he broadbrushed in ideas about Bermuda paintings and then, at the end of each day, rubbed them off the masonite panels that he was using with rags dipped in turpentine. And he looked at slides of Bermuda as well as those of Mexico. Presently he painted *Mexico: Street and Cathedral in Distance* (pl. 52) with highly developed color. The reconstructed image emerges from strongly drawn shapes; it frees Wally's fascination with the sparkle of Mexican color and light. The clouds, with unusual broken-color shadows beneath their earth side, float above a silhouette of the cathedral and city. In the foreground small houses of warm, muted colors recede along a space determined by Wally's ubiquitous road or passageway; Wally thus finds space in which to free his brush from the requirements of strict architectural form and to provoke from passages of paint mere suggestions of a cityscape. In the emotion of painting recollected tranquility, Wally unleashes his brush: it does not now dance to a noticeably French tune, it dances quirkily, jazzily.

In time, he painted several Bermuda scenes in which his characteristic streets exist between buildings, begin and go nowhere discernible. In these paintings from the early seventies, the color is heightened and warmed; flowers tumble over the street sides of walled gardens; bright shutters surround or protect windows (pl. 53).

The paintings, similar in composition and underlying form to many produced earlier in response to France and Italy, embody a different mode and evoke a different feeling tone. They are gay; flippant passages of paint suggest cascades of bougainvillaea; bright colors overpower shadow.

The Frank Rehn Gallery planned to show Wally's work in 1974. Wally, anticipating the show, talked hopefully with Fred Conway. This time, he confided to Fred, he would be noticed; now, in New York, the art scene had become more open, more accepting of—perhaps more interested in—individual voices. As the aging buddies drank and talked, their Sweetheart and Rosebud characters emerged to banter and joke. Behind the protective masks of these persona, these psychic puppets that tripped and gestured as directed and that spoke with removed voices, the cronies both knew that Fred was ill.

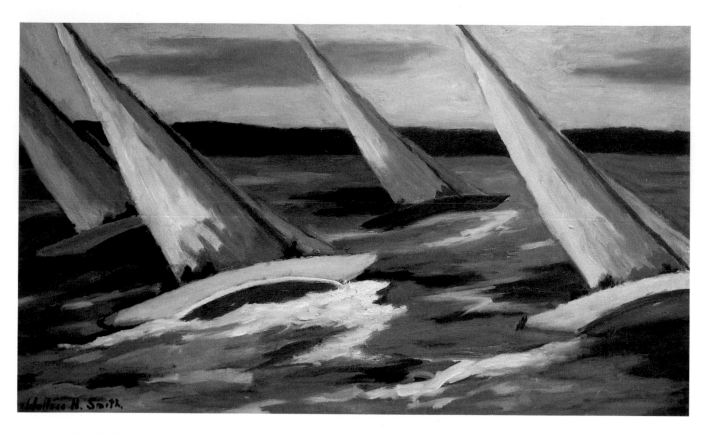

46. *North Wind*, 1970s oil on artist board, 24" × 40"

Wally wanted to produce a show of work that would delight Fred, who, for
Wally, was still, with Peggy Bacon, his most reliable messenger from the Big Boys.

Fred, often an unwilling messenger, wanted to deliver an ultimate report. In
1973, just before his death, Fred wrote:

Wallace Herndon Smith belongs to the tradition of American painting which includes
such artists, among others, as Homer, Eakins, and Ryder.

To become adept in a tradition requires long years of painting from nature, along with
the study of composition and the study of the heritage of painting, those truths which
have seeped down through the efforts of countless artists through the centuries.

Wally has worked most of his life perfecting his craft. When the good and the bad in
painting crossed the Atlantic and many artists were pressured by powerful forces to tinker
with what they deemed freedom, Wally—who is not easily stampeded—proceeded to
work in "the tradition" and to follow the high goals he had set for himself. This dedication
through the years has paid off.

It is his nature, when looking at a painting (say a Rembrandt) to ignore any messages,
heroics or protests, and study the way the paint is applied—in the main, formal elements.

His instincts and muscles caused him to study some of the modern ideas, mainly
French, regarding color and composition. These slowly began to incorporate in his
painting. This, along with that special skill in his craft of painting, give his painting a
new "look."

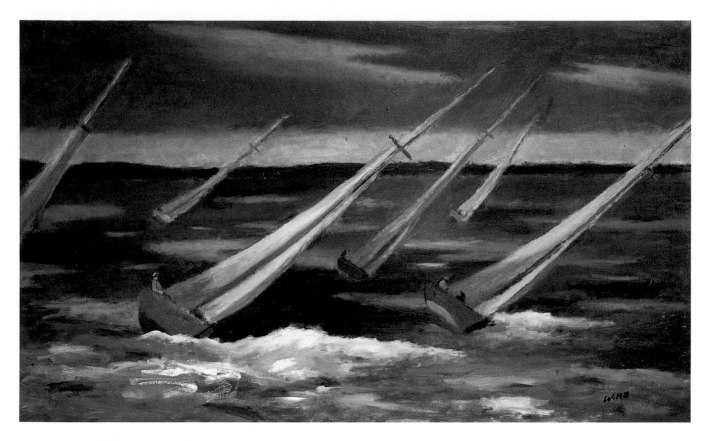

47. *Racing Sail Boats*, 1970s oil on artist board, 24″ × 40″

His composition is more structural, the forms more related and moving closer to the eye of the beholder. Color is his favorite love—he likes it almost as much as French cooking and whiskey—so much so that his composition seems to be a support for this color.

Color in painting is a difficult terrain. It can be only partly learned. Its more expressive and beautiful factors must be triggered by flashes of intuition, hunches and whiskers. Wally moves in this area extremely well, and it is one of the finest facets of his talent.

I have traveled, painted, laughed and drunk with this beloved friend, and in the days of ''instant creativity'' when many artists seemed to have thrown the baby away with the bath water, it is reassuring to see in his work that painting is, indeed, alive and well.[1]

1. Fred Conway wrote and delivered these remarks in St. Louis in 1973.

Fred Conway died. Wally was devastated by grief. Nothing, he thought, would ever be quite right again. He sat alone in his studio, drinking and remembering Fred. He penned his eulogy for Fred into a sketchbook:

He was my best friend and I loved him. I called him Rosebud and he called me Sweetheart. There are many here today who also knew him well and I'm sure that they can understand how easy it was to care deeply for him. Fred Conway loved people and gave of himself so warmly in their presence that he had a host of friends and grateful pupils; so many, in fact, that his influence on the art life of St. Louis from 1924 on was almost incalculable. Others will tell you more about his wonderful personality, his love of life, his gaiety and infectious laugh and almost childish playfulness. . . .

He was so light hearted and gay, he didn't care to linger too long on somber subjects or attitudes. His was a delightful sense of humor which I luxuriated in for many years and it was a very real sense of humor because he had the rare ability of laughing at himself. Let me give you an example. Some years ago he had a commission to paint a very important full length frontal portrait of a lady in a blue gown. The size was four feet by eight feet and since I saw him struggling with it I admired but had no comments because he always jokingly said he was above criticism. I asked why: "Well, Sweetheart, I'll tell you. I'm not above flattery—that's o.k.—but when criticism is not that I call it slander. Let's have a drink, " he said. "No, thanks, Rosie, not at noon."

"It's not noon, you jackass, its 12:30," he said as he poured two.

"That's a beautiful job, all right," as I lifted my hand as he always did when judging the areas in one of his paintings. "Thanks, Sweetheart. That's all I want to know."

"Only one little thing it needs," I said.

"Huh?" came the reply.

"It's too heavy on the right. It would balance perfectly if you could have cut a foot off the left side." "That's what I call slander" he yelled and pretended to kick me into the lunch room.

A week later he phoned and asked me to come in. He said, "You weren't serious about my cutting a foot off the board, were you? "Yes, but I didn't mean to offend you Rosie, because lord knows what you're doing."

Long silence.

"I'll be back in a minute. Must make a phone call." He returned. He sat in silence. A short knock on the door and in walked Helen (wife) with a portable saw. He asked her to hold one end of the board and me the other while he applied the lethal weapon and off went the right foot of the board.

"I kind of like it better myself," he said as we went in to lunch, and he laughed himself almost sick over the whole episode. "Seems to balance better—can you see that Sweetheart?" "Yes, I can." I said.

But the thing I want to emphasize is that he told everybody about this, whereas if he had a grain of vanity in him he wouldn't have thought it funny and he never would have mentioned it.

The exhibition at the Rehn Gallery came and went. Wally's work caught no more public attention with this exhibit than it had in previous exhibitions. Charles Buckley, the director of the St. Louis Art Museum, however, was among the viewers on opening night in New York. He looked carefully at Wally's work; with his trained eye, he studied the paintings from various distances, moved in close and peered at the brushwork; he found magic in them. Very soon after his return to St. Louis, he began to mount an exhibition of works by Wally and by Marie Taylor.

Buckley's genius in showing jointly the work of the two St. Louisans might not have been readily apparent to the audience. Taylor, an accomplished painter, was known primarily for her sculpture of animals. As stubbornly her own person and as sternly the keeper of her own talent as Wally, she persistently worked against the mainstream. And, like Wally, she worked almost alone and in St. Louis. She drew images from fieldstones; Wally pulled his from the stones of memory.

Buckley understood the affinity between the artists and their work. He introduced Wally to his hometown audience:

Trained in a mode of perception and in a painterly manner that derives from late nineteenth century and early twentieth century French painting, Wallace Smith approaches color somewhat indirectly. He responds to it for its own sake, to be sure, yet he never neglects the expressive and decorative role that color must be allowed if the painting is to be successful. . . .

Wally Smith has great admiration for any painting which has been created with love, and respect for what he knows can be achieved through a harmony of form, light and color. Much of what he admires is present in French painting and one finds revealing clues to his personal taste among the reproductions on the walls of his studio, works by Matisse, Cézanne, and Modigliani as well as others of this generation, notably Albert Marquet.[2]

2. Charles Buckley, *Marie Taylor and Wallace Smith*, Exhibition Catalogue, City Art Museum, St. Louis, Missouri, 1974.

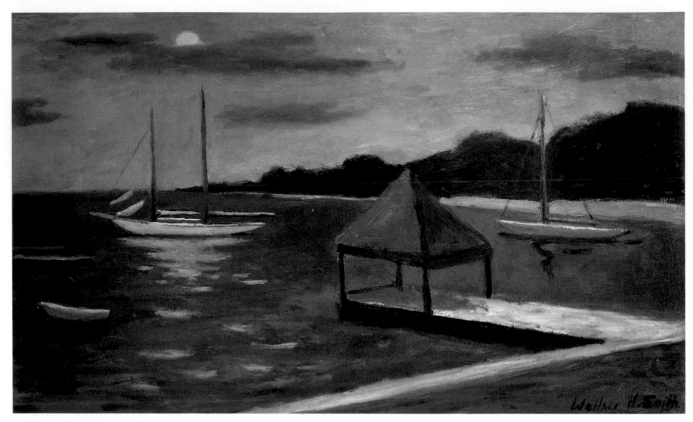

48. *Harbor Nocturne,* **1960s** oil on artist board, 24″ × 40″

George McCue, who had observed and commented on the tides and fortunes of art in St. Louis during the time when both Wally and Marie Taylor were reaching maturity as artists, looked at the works of his fellow St. Louisans with exactly the cosmopolitan eye that was required for work which, for entirely different reasons, might seem puzzling to an audience. His words, in each instance, were chosen to refute the criticism he imagined might be aimed at the work. Of Taylor, he wrote:

There is no sentimentality or cuteness about Marie Taylor's creatures. They are realistic to the point necessary for identification by means of minimal surface completion. The play of light and the viewer's discovery do the rest. They are sensuously inviting to be petted and stroked.

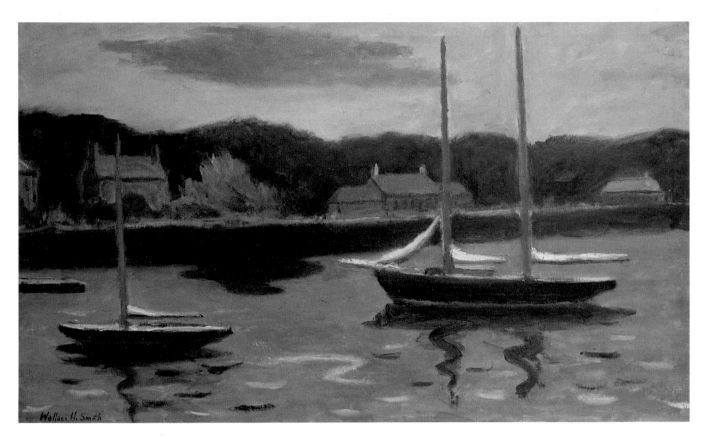

49. *Black Schooner,* 1960s oil on canvas, 24″ × 40″

McCue rightly urged the viewer not to assign sentimentality to stone-hard works that were cut as much by the artist's sharp and tough mind as by the tools she wielded. Similarly attuned to the misperceptions that might easily fall to Wally's work, McCue addressed both the issues of seeming casualness in Wally's work and the relatively small scale of his paintings in a time growing accustomed to wall-size canvases. Giving attention first to the construction of Smith's work, McCue wrote:

Wallace Smith's paintings of companionable, easy-going subject matter, and the kind of French coloration that makes them glow on the wall, produce consistent pleasantness out of well-understood discipline of forms.

There is a firmness to his sense of design and to his color-supporting structures that puts a durable foundation under the apparent looseness of his compositions. He works in a well-established tradition of sunlit realism, but he makes modern statement of juxtaposed, semi-abstracted forms; his paintings are consistently vigorous and fresh in spirit.

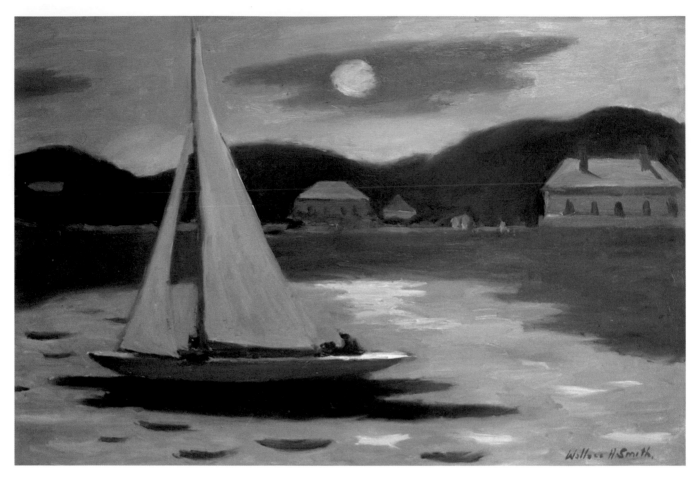

50. *Harbor Light*, 1960s oil on artist board, 24″ × 36″

McCue would have his readers take seriously this artist whose work in the
museum show could be viewed superficially as pleasant but not very serious.
McCue understood that Wally's work was based on thinking, on decisions and
choices that he then obscured in the composition; he had learned his lessons well
from the French painters of the nineteenth and early twentieth century. Moreover,
McCue knew that his readers were likely to have heard (or heard of) Wally's
attacks on abstract art and, taking him seriously in his rejection of modernity, be
prepared to see his work as strictly representational. McCue's excellent eye told
him otherwise: here, he saw, was an artist who eschewed what he considered the
excesses and formless abysses of Abstract Expressionism but who, nonetheless,
worked from abstract principles of organization and structure.

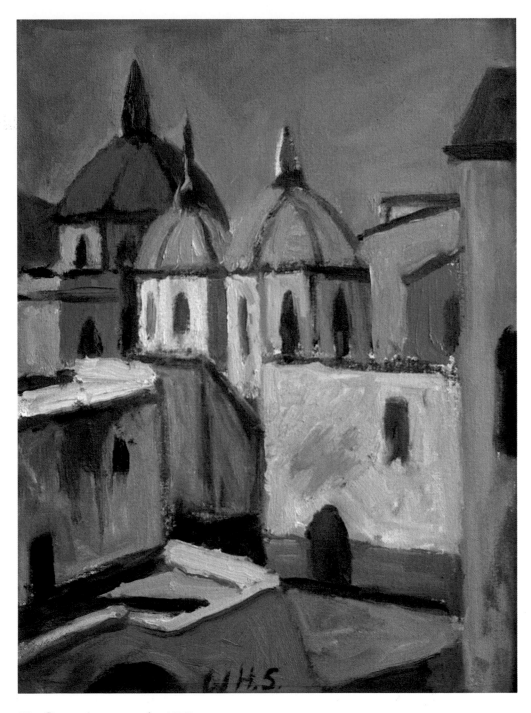

51. *Guanajuato,* early 1970s oil on artist board, 12″ × 16″

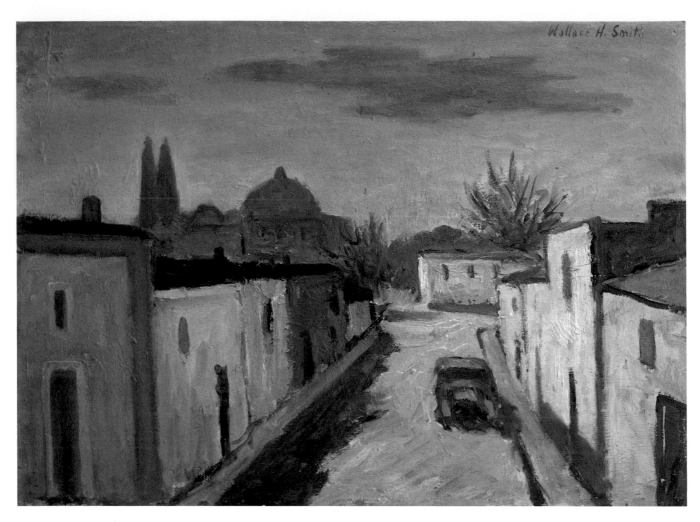

52. *Mexico: Street and Cathedral in Distance,* **early 1970s** oil on artist board, 27″ × 36″

The St. Louis art critic recognized Wally's modesty, a trait not often associated with the joking painter who wasted no opportunity to speak out on the aesthetic bankruptcy of abstract art. McCue called attention to Wally's sense of scale and to his sense of rightness in paintings: "Smith is not inclined to make his subjects larger than life, but rather seems to find life agreeably well stocked with the kind of visions that suit his personal exuberance and untroubled outlook."

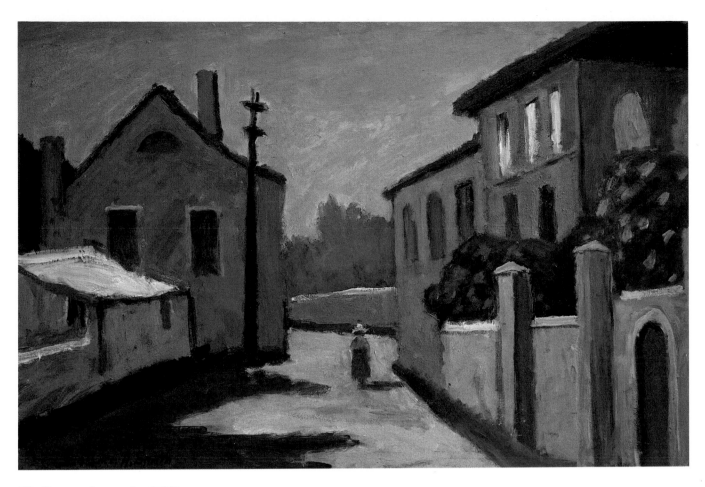

53. *Bermuda*, early 1970s oil on artist board, 24″ × 36″

Taken together, Smith and Taylor performed similar rituals in the making of art. Each, on the scale close to the human hand and natural eyespan, took what was provided: Taylor in the found stones and Smith in the found views of familiar scenes; Taylor in the images lurking in her stones to be freed by her eye-imagination; Smith in the images lurking in his imagination that found shape in the external world as he transformed it. Each artist, working from the ingredients of his form, recreated experience to get closer to reality, not farther away from it. Both understood that a too-specific rendering of observed fact limits imagination and, therefore, closes off possibilities for comprehending generality, universality, or abstract truth, however fragmented.

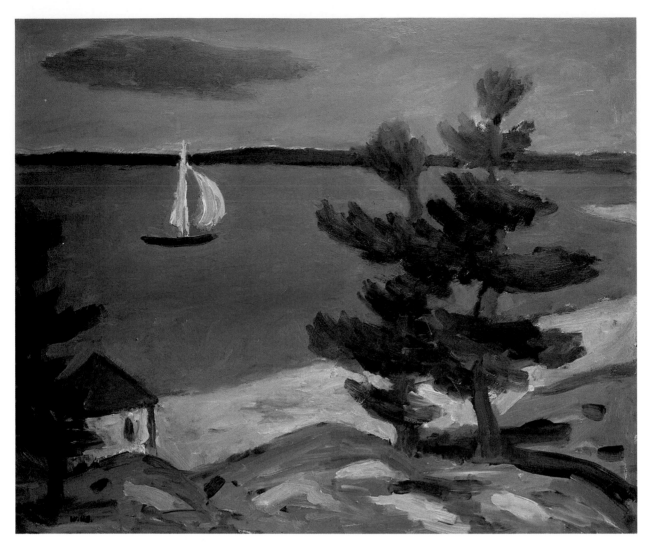

54. *Beach with Pine Trees,* **early 1970s** oil on canvas, 25″ × 30″

Early in the summer, after the exhibition at the St. Louis Art Museum, Wally and Kelse went to Harbor Springs for the summer. Jay, now living in London and working to master the craft of playwriting, would join them. There, amidst the familiar dunes and pines, in walking distance of downtown Harbor Springs, they would sail and be pleased to be together (pl. 54).

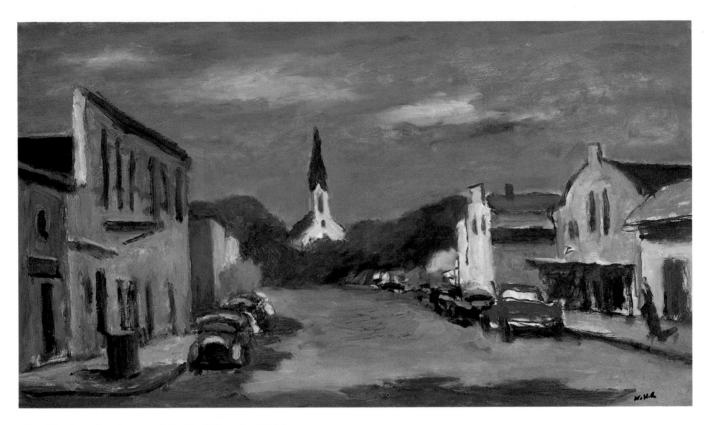

55. *Harbor Springs with Red Truck,* 1960s oil on canvas, 24″ × 36″

Harbor Springs remains a small, sleepy-under-the-sun, totally charming American town, a resort of the sea. People return summer after summer, generation after generation, to the points and edges of Lake Michigan. There, they stroll down the streets, pause at stop lights, greet friends. Main Street here could be Main Street of any small American town, a street still edged by peace and space, by friendly folk who know and care about one another. Harbor Springs, blessed as a small town, privileged and protected, seems far away from the stresses of urban America (pl. 55). Here, over the years, Wallace Smith has renewed each summer his own personal archives of emotion and imagery.

Shortly after dawn each morning that summer, Wally withdrew to his studio above the garage. He missed Fred Conway sorely. Only Peggy Bacon had equalled Fred's contribution to Wally's life as an artist.

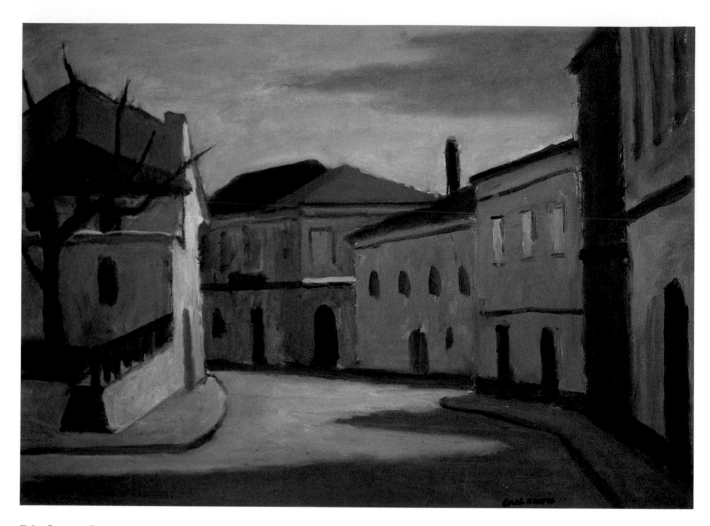

56. *Street Scene: Winter/Europe, 1974* oil on artist board, 21" × 29"

During this time, reflecting on the past and missing Fred, Wally painted *Street Scene: Winter/Europe* (pl. 56), a moody scene in desolate, muted colors, with barren trees and stark buildings. This stripped-down and winter-bleak painting escapes total somberness, however, through Wally's insouciant passages of green shutters and of a yellow building, a pinkish building, and an orange roof. These more vibrant colors set against the winter hues rescue the painting from unremitting gloom. From grief?

At the time of its painting, Wally did not publicly identify the European winter scene as a requiem for Fred, but many years later, his eyes moist, he said, "I wish Fred Conway had seen that painting. Would he have liked it?"

He turned then to a painting from the little balcony outside Kelse's bedroom in their Harbor Springs summer house. The painting and all of its parts emphasize verticality that is only slightly offset by the horizontal elements of the balustrade. A lone sailboat in the distance, not necessarily moving, places the water surface in

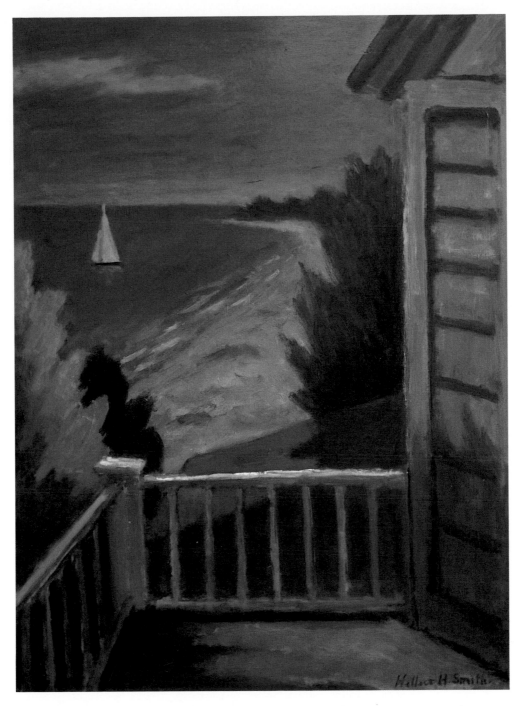

57. *From the Balcony,* **early 1970s** oil on artist board, 36" × 27"

58. *From the Bluff,* **early 1970s** oil on artist board, 16″ × 27″

space and contributes to the mood of the picture. A slightly ominous cloud introduces a brooding tone to the predominantly quiet and calm painting. As shadows throughout the painting meet the vertical structures established in the shape of the painting, in the shutters, and in the balustrades, they serve also to weave a pattern of light and dark across the surface of the painting and to emphasize the serenity of the scene.

If the European winter scene expunged grief, then the painting from Kelse's balcony affirmed Wally's abiding love for and dependence on Kelse, a source of serenity and calm strength. By the end of summer, Wally turned his attention to his beloved Harbor Springs. From the bluff above the town he painted two small pictures of the harbor itself (pl. 58 and pl. 59). Both show the little town, seen from above, and show the meeting of town and shore. The point, a jut of land that separates the harbor from the sky, marks the area of sailing races and, in one of the pictures, such a race frets the surface of the lake.

Making these little pictures awakened Wally's interest in Europe: he wanted, he told Kelse, to go to Europe and visit again the museums, wanted to be in the presence of the great painters. During the last trip to Europe, Wally transformed

138

59. *From the Bluff with Boats*, **early 1970s** oil on canvas, 16″ × 27″

the familiar scenes of the continent yet again. This time, after years of painting the
architecture and spaces of Europe, he produced a series of bright, often joyous,
treatments in which familiar objects veer more than ever toward abstract essence,
which encourages Wally to boldness.

As a painting, *Lady in Lavender Blouse* (pl. 60) gave Wally an opportunity to
employ a minor color—lavender—as a major compositional theme, a deliciously
audacious touch. The lady in the lavender blouse or, more precisely, the lavender
blouse on the lady, established the color theme and the subject of the painting.
Lavender is then employed by Wally as the element underlying most of the colors
in the painting; it is used intentionally to connect the architectural units. Wally's
strong architectural drawing, clustering, and massing of buildings, here as in other
paintings, lets him organize his work around a series of fully realized planes
within that almost brutal superstructure. But within his strong composition, Wally
weaves a very subtle, almost feminine, spring-like lavender motif—the woman's
dress; to the left of her, a shutter on a second story window, to the right of that
a facade or side street in which the lavender nudges orange to suggest a building

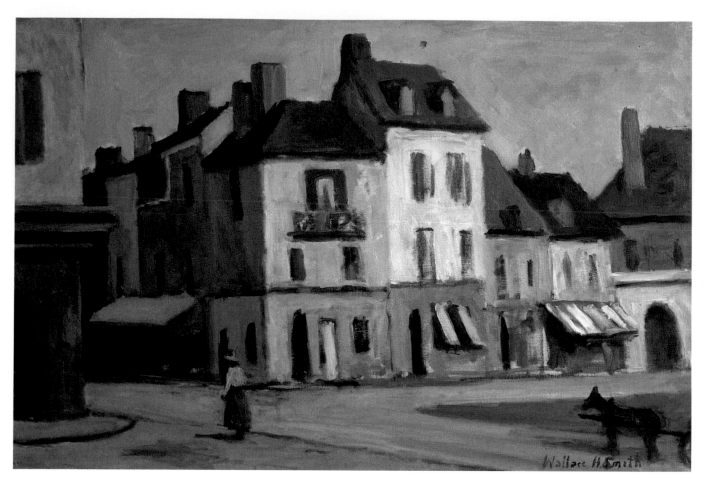

60. *Lady in the Lavender Blouse*, 1970s oil on canvas, 16″ × 27″

in shadow. Lavender laces its way in and out of the white in the corner building, underscoring the balcony on the front of that building; it creeps up again under the overhang of the brown roof of the tallest building; it drops down to be the color of the roof of the adjacent building on the right; it drifts into the shadows and dwindles as the space drops back to the right of the painting. Wally's almost contrived use of lavender finally floats the color free; like a melody carried by a flute, its capricious presence enlivens and brightens the overall picture. Wally gently celebrates with this painting much that he honors in Europe: its spaces, its patina, its light; and, especially, his long and congenial association with its artists.

In 1975 Wally, reflecting on his own career as a painter, said that "every great painting, in my opinion, has an abstract basis, but I don't think any great painting has ever been completely abstract."[3]

At about this time, he produced three paintings that exactly illustrate his position. All three paintings, constructed in St. Louis after visits to Europe, use a particular color—as it happens, all use yellow—as the subject of the painting.

3. Wallace Herndon Smith to Mary Kimbrough, *Glove Democrat*, "A Painter Whose Message Is That the World Is Beautiful," November 12, 1975.

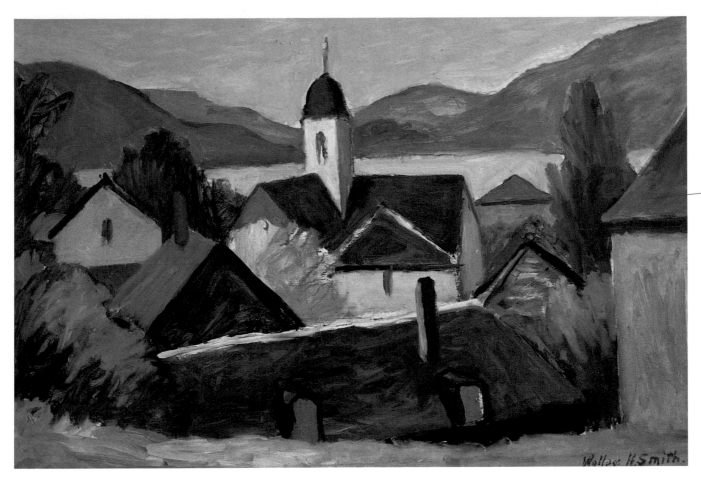

61. *Talloires*, 1970s oil on artist board, 24″ × 36″

In *Talloires* (pl. 61), yellow trees surround a French village, echo the shapes of distant mountains, and enliven the surface of the painting. The village, viewed from slightly above, contains reassuring similarities to Harbor Springs: a steeple, a lake, small buildings. The similarity between the two small places, like the abstract quality of the trees and the massing of buildings, reassured Wally.

Yellow Trees and Monument (pl. 62) is composed as a vertical cityscape in which trees and sky seem to mitigate against rigidity and harshness of architecture. The architectural shapes, depicted almost abstractly, identify mass and set the mood of order and stability, of hesitant somberness. A single cloud hovers near the center of the sky and breaks an otherwise very blue and brilliant sky, which, without the anchoring effect of the architectural masses, would tend to play merrily the role of mere backdrop. The monument focuses attention at mid-distance; it is a point toward which the trees march in balletic cadence. The trees, unlike the buildings, are painted in active fashion, which gives them presence on the picture's stage as appealing dancers.

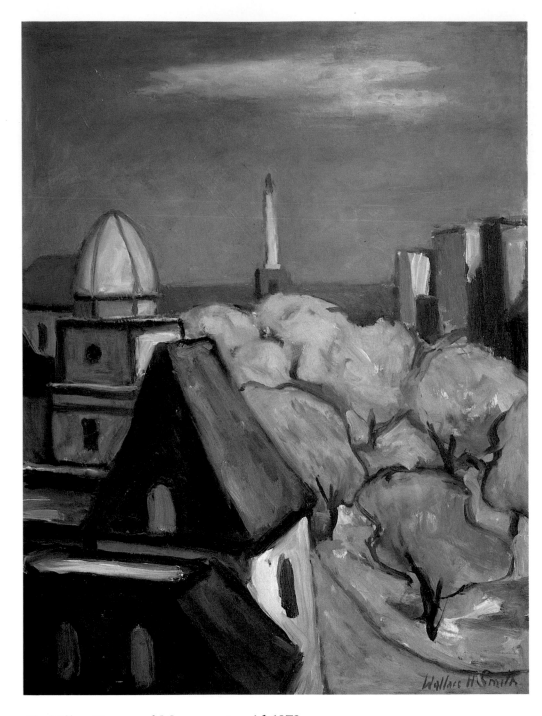

62. *Yellow Trees and Monument*, mid-1970s oil on artist board, 36″ × 27″

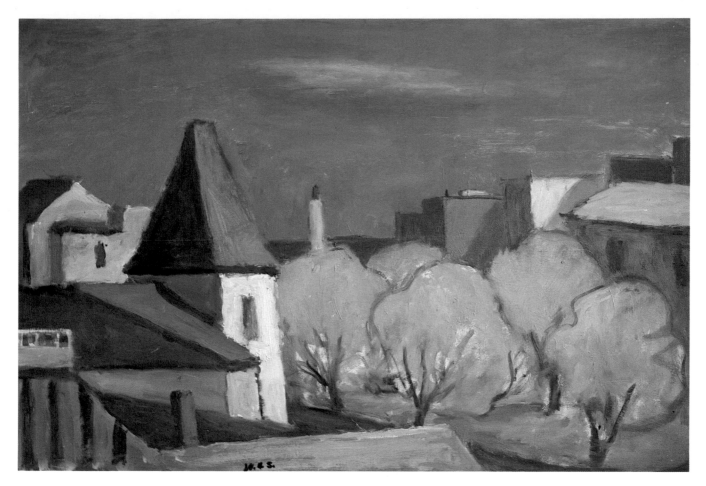

63. *Yellow Trees: Portugal,* mid-1970s oil on artist board, 24″ × 36″

Yellow Trees: Portugal (pl. 63) is a horizontal composition from this stage in
Wally's painting life; it engages the same elements as *Yellow Trees and Monument.*
The trees here, while more upright and less active, nonetheless recall the dance-
persona of the companion painting. The awning in the lower left iterates the blue
of the sky, which, as in *Yellow Trees and Monument,* is a saturated and assertive
blue that could easily dominate a painting if not checked by composition, as in
this case it is by the bold yellow.

As Wally neared eighty, he was an affable, impish, reflexively polite, and urbane
man who publicly acted the role of jester. A drinker and a talker, a dancer and a
party-maker, he had proven himself a good friend within the brotherhood of
artists.

In 1981, he began but never finished *Cathedral* (pl. 64). This important painting-
sketch reveals the artist at work in his late years. He first lays in a wash of color,
the notations, the areas that he plans to develop and divide. In this drawing-
toward-painting, despite its very sketchy state, he suggests that the color would
have been in the process of finishing it, taken up in key and developed and

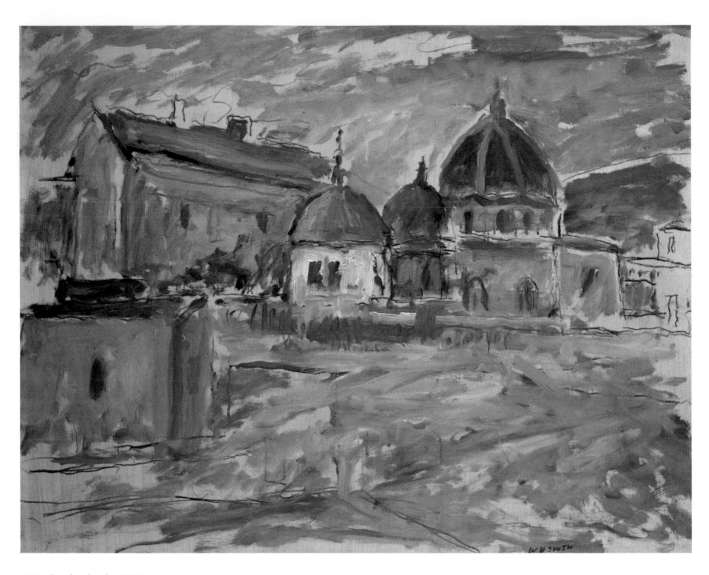

64. *Cathedral*, 1981 unfinished oil on artist board, 25″ × 29″

lightened toward considerable brightness. Already an interesting composition
with its band of buildings in the upper central portion of the middleground and
its unresolved foreground, the sketch provided Wally several directions for logical
development and, as well, numerous paths for impudent and contrary work—
directions not to be discounted: they could have captured Wally's imagination.

 He might have let the strong diagonal dominate in the lower left. He might
have worked from the street intersection or a building at the left to define and
develop themes and moods. Unresolved as to which direction he will take to
complete the composition, Wally put it aside.

 Working for the Big Boys had always been that way, Wally decided: Some tasks
can never be finished; some questions never answered. But he liked working for
the greats. What could have been better?

Index